ARTS, GOVERNMENT AND COMMUNITY REVITALIZATION

To my parents, advisors and C. Gable
for their patience.

Arts, Government and Community Revitalization

JAVIER STANZIOLA
University of West Florida

Ashgate

Aldershot • Brookfield USA • Singapore • Sydney

© Javier Stanziola 1999

Published by
Ashgate Publishing Ltd
Gower House
Croft Road
Aldershot
Hants GU11 3HR
England

Ashgate Publishing Company
Old Post Road
Brookfield
Vermont 05036
USA

British Library Cataloguing in Publication Data
Stanziola, Javier
 Arts, government and community revitalization
 1. Community art projects - United States 2. Community
 development - United States
 I. Title
 307.1'4'0973

Library of Congress Catalog Card Number: 98-74439

ISBN 1 84014 951 5

Printed and bound by Athenaeum Press, Ltd.,
Gateshead, Tyne & Wear.

Contents

1 Cultural Coalitions

Cities emerge out of the intricate coalitions people form with each other to achieve their own goals and respond to their own motivations. When these coalitions break down, any sense of common purpose disappears only to be replaced by conflict and instability. The technological advances of the last fifty years have drastically changed not only the goals of most members of society, but also the means they have to obtain them. As a result, people have grown less dependent on close proximity, neighborhood associations, local corporations, and a local work force. In America, the Federal government reinforced this trend by funding a massive highway system that in some cases divided entire Downtown communities, and in some others stretched out the boundaries of the city. The reality of the 1990s has been, Kotkin (1998) points out, a continuing out-migration of middle class people, companies, and opportunities from most urban centers. Counteracting this phenomenon, new coalitions of local officials, business owners and concerned citizens have been formed since the early 1960s with the purpose to save and promote what is left of the cities. For cities that have a comparative advantage on tourism, heritage, arts and entertainment, these coalitions are run by groups of artists, nonprofit arts managers, preservationists, local officials and restaurant and hotel owners. To promote their efforts, these coalitions design marketing strategies that tackle primarily the market of highly-educated, high-income, trend-setting people that are capable and willing to visit the city and, most importantly, to sponsor plans for redevelopment (see Appendix A).

For centuries, such cultural plans have proved to be successful in the short run. In eighteenth century Spain, Charles III used the Museum of Science, the Botanical Gardens, and the

1

Planetarium to improve the dilapidated image of the area surrounding the south entrance of Madrid (Rico, 1997). Similarly, culture was used in the United States to alleviate the cruelties of the Depression. Writers, painters, sculptors and musicians were hired to be part of the artistic projects funded by the Works Program Administration. These projects provided a stable source of income for otherwise unemployed artists while at the same time helping the federal government to promote its own agenda and remind Americans of their common goal of more prosperous times. More recently, New York City formed its own cultural coalition to improve the image of 42nd Street at Broadway and promote tourism and investment. What remains to be proven, however, is whether or not cultural coalitions can support long-term development programs and provide more than the image and the public space needed to engage in a "real" redevelopment project (see Chapter 2). Trying to prove just that, cultural coalitions are constantly looking for new and better ways to assess the impact they have on the community, and to evaluate their implementation methods. This assessment should serve as a means to identify the strengths and weaknesses of the coalition but in reality is used as promotional and political tools to justify more private and public funding (see Chapter 3). Moreover, the techniques used to evaluate this impact tend to ignore that the net economic benefits that trickle down from cultural strategies are minimal. Absent from these evaluation studies is an account of how arts organizations and festivals only create low-paid and low-skilled temporary jobs that do not alleviate the structural unemployment that plagues most cities in the world. Even more ironic are the claims by most of these studies that the arts provide the ethnic and cultural glue for neighborhood identity and cohesion. In reality, cultural strategies are about making cities less democratic and less diverse by appealing to more affluent people and displacing social and ethnic minorities. However, nonprofit arts organizations in America have

started to realize that without a serious commitment to arts education programs, symphony orchestras and the ballet will always be more about creating social distinction than remedying ethnic conflicts and promoting arts democratization.

Miami Beach, Florida serves as a perfect case study of the role cultural coalitions have in economic redevelopment (see Chapter 4). Just as the Miami Beach Redevelopment Authority had decided to demolish most of the dilapidated 1930s Art Deco buildings to make way for a new resort area, a small group of dedicated preservationists spent more than three years lobbying for local and federal support to make the "Old Miami Beach" area a registered historic district. Meanwhile, a few blocks away, several nonprofit arts organizations were taking advantage of low rents and migrated to the "Beach" to rebuilt empty warehouses and abandoned buildings. Preservationists and artists worked together to promote their vision of a new Miami Beach, sometimes with the opposition of city officials. Even today, 20 years after Old Miami Beach was designated a historic district, a conflicted cultural coalition still works together to promote tourism and investment in the community. In Chapter 4, a conceptual model will be formulated to evaluate the impact local incentives to nonprofit arts organizations and to historic preservation has had in the short run on the redevelopment of Miami Beach. The evaluation will also address the social and cultural reasons for development, its consequences and the nature and characteristics of the agents behind this cultural coalition.

2 Urban Redevelopment
and the Arts

Introduction

For nearly a century, cities have followed a mass-industrial model of development based on large-scale manufacturing and multinational corporations. Accordingly, only an economic surplus in these sectors could produce or release enough resources to fund Riveras on city walls or Bernsteins on television. With the transformation of the manufacturing industry and the advent of the information age, large corporations have relocated to less complex edge cities. This phenomenon has changed the arrow of causality and many cities in America and Europe have found a powerful ally in the arts and historic preservation to promote urban redevelopment

Cultural Strategies

In search of affordable artistic venues, new artists and nonprofit arts organizations move in to a blighted community, take over empty buildings and warehouses and start a revitalization process. By simply re-painting studios and buildings, decorating store-front windows and programming artistic events in public areas, artists increase the value of the places they occupy and make them attractive to the same companies and investors that abandoned them in the first place. Similarly, listing buildings and monuments as "historic" guarantees the community the federal and private grants needed for the appropriate management and preservation of these buildings. These funds ultimately stay, it is argued, within the community and turn low income areas into middle to upper

middle class communities, which in turn attracts more people from the suburbs not only to visit but also to move in to the area.

The apparent success of Liverpool, Buenos Aires, Bilbao, New York's SoHo and 42nd Street, Downtown Seattle, West Los Angeles and Miami Beach's South Beach in using the arts as a tool for redevelopment has prompted other cities in the world to do the same. But as Bianchini (1993a) warns us, these cultural strategies are frequently dismissed as yet another tool used by local authorities to compensate for their inability to continue the expansion of traditional social policies. According to Harvey (1993), Latin American governments use the traditional arts and crafts fairs as tool to reduce the burden of unemployment among Indians and artisans. Cultural strategies work as a "carnival mask", critics argue, and conceal - and even increase - the growing social inequality, polarization, and conflict within cities. These problems only arise, neoclassical economics tells us, when the exchange value (the amount of money one can get for something in the market) and the use value (the amount of utility or pleasure one derives from something) are not equalized. But as Logan and Molotch (1987) explain, this discrepancy is intrinsically a part of arts-led redevelopment programs. The central conflict in cities is between rentiers (who strive to increase the market value of land) and the residents (who fight the commercial expansion that damages their use value). As cultural strategies take place, the value of the land increases. The original residents - mostly minorities and immigrants - find themselves unable to afford their properties since the cultural strategy neither include them in their plans nor prepare them to take advantage of the new situation. Eventually, they are forced to move out and leave space for more sophisticated residents. Gentrification occurs. This conflict is intensified when the very owners of commercial properties - mostly artistic visionaries - oppose the commercialization of the area that large real estate agencies propose. Artists, victims of their own success, eventually find the places they helped rebuild

too expensive and are also forced to move out and leave space to restaurants, hotels and retail shops.

Evans (1996) also warns us about the potential of using the arts as a tool of revitalization when not only its workers but the very arts organizations suffer low pay, episodic work, poor levels of job satisfaction (high turnover), and low operating margins. As Zukin (1995) emphasizes, culture suggests a labor force that is well suited to the revolution of diminished expectations that began in the 1960s. Artists are supposed to live on the margins; they are used to deprivation; flexible on job tasks and work hours; do not always join labor unions; and present a docile or even "cultured" persona. These qualities make them desirable employees in low-paid service industries. As Kotkin (1997) points out, the sporadic nature of the cultural sector reduces its ability to create economic opportunities for the population of these cities.

Cultural policy makers usually are forced to choose between organizing transitory programs or events (e.g. festivals) and permanent facilities (e.g. concert halls, libraries) when designing their cultural strategies. Maintenance costs and loan charges on cultural buildings are often so high that they absorb most of the resources available. González (1993) points out that almost 80% of the cultural budget of Bilbao (Spain) City Council in 1986 was spent on the renovation and maintenance of buildings for cultural use, which left relatively little for the funding and programming of cultural activities. Furthermore, Vaughan (1980) argues that festivals, though they may occur only once a year, can become so popular that they may become the symbol of a city. In fact, Vaughan argues, festivals are tangible, major economic assets that produce a measurable financial return. These benefits added to their very low fixed costs make festivals the preferred alternatives for city planners and nonprofit arts organizations.

Other critics argue that cultural strategies only exacerbate the ethnic chaos prevalent in blighted communities as gentrification and a higher number of elitist, high culture events

are programmed as an essential part of arts-led redevelopment processes (Marquis, 1995; DiMaggio, 1986). Regardless of their bloody past or current social tensions, cities are forced to become "a happy face" embarking in a prosperous development path (Zukin, 1995).

If cultural strategies are plagued with such drawbacks, how can we explain the increasing number of cities in the United States that rely on such strategies to promote their redevelopment plans? And how can we explain the success of some of them? To understand this phenomenon, we need to explore the nature of the nonprofit arts sector and its development in the last decades, and understand the coalitions it creates with the public and private sector.

The Arts and the Nonprofit Sector in America

Charles Dickens and Tocqueville both thought Americans were too preoccupied with everyday concerns and too busy to worry about the arts. This attitude and the American ideals of freedom and decentralization encouraged Congress to put the arts on the back burner. As a result, Americans rejected the idea that the arts should be federally funded, leaving the creative arts in private hands where the government could do nothing. This very private ideal accentuated the class distinction between the people who could afford to pack and leave for Europe for months to enjoy history, culture and arts, and the ones who could not. The urban upper class dominated the world of high culture and their very visibility almost assured them whatever little public funding was available for the Arts. Any other form of artistic expression was deemed as popular vernacular traditions not worthy of public support. By 1858 Congress had managed to subdue the fear of centralized power and had approved the creation of a National Art Commission, but it would be many decades before Congress itself and the American people in general would accept the legitimacy

of this commission (Levy, 1997). With the Civil War and WWI Congressional interest in the arts disappeared completely. Notwithstanding the Chicago World's Fair, the City Beautiful movement and numerous authors writing about the coming of age of America, very little was done to try to democratize the arts. The Depression did, however, offer for the first time the opportunity to use the arts as an agent of change or development. The Federal Emergency Relief Act (FERA) granted relief to artists that had been laid off by magazines, newspapers, and theaters. Very soon conservative politicians pushed for legislation to use those same funds to establish projects like the Writers' Project, the Theater Project and the Music Project. As the arts entered further into the political arena, Levy (1997) explains, politicians started to look at murals, novels, concerts and other objects of art as a political tool. The government rejected any hints of abstraction and only funded artistic programs that were communicative and practical in terms of its language, visual style and theatrical and musical performance. Even though the funds for the arts never amounted to a significant proportion of the overall budget, it was the first time Congress faced the many issues that concern arts funding today: regional favoritism, experimental arts, frivolity, waste, politically subversive activities, bureaucracy, lobbying, and public funding competing against the for profit entertainment sector. And most importantly, the Projects came to confirm what most Americans knew all along: that arts sponsored by the public sector cannot be anything else than politicized. By the end of the 1930s the federal government had managed to define the nonprofit arts world as we know it today: arts administrators must be artistically and politically sensitive, artists must work in groups or large institutions to increase their chance of being funded, solo artists are considered dangerous, and government officials function as managers of the egos and artistic visions of temperamental artists.

Right after WWII, America started this rhetoric in the form of a crusade pressing its citizens to attend arts events. As

Americans realized that cultural activities were becoming more elitist, Marquis (1995) explains, they decided to organize groups and associations to bring arts to the masses. The most powerful of those associations took the form of nonprofit organizations since they are allowed to engage in voluntary price discrimination in the form of private donations.

As DiMaggio (1987) explains, the early nonprofit organizations proclaimed service to the entire community, but in reality were creating an image of the arts that made it less and less accessible to the general public. Furthermore, these nonprofit organizations were run by coalition of wealthy trustees, artists, and poorly paid arts administrators. These trustees would favor decorum and exclusivity and prefer to serve a limited and exclusive public. Even when promoting the democratization of the opera, orchestras, and the theater, nonprofit organizations were actually widening the distance between the performer and the public by inviting audiences to experience the "divine" and "sublime". This distance, according to DiMaggio, permitted the mystification needed to define a body of artistic work as sacred.

By the mid-Sixties, the emergence of institutional funding, large public cultural agencies and city cultural affairs councils changed this situation. Arts organizations were now required to prove sound fiscal management, organize outreach programs and find any other sound logical argument that could justify continuous private and public support. These goals were rapidly assimilated by these organizations who commissioned a myriad "demand studies", "attendance surveys" and "production function studies" to support their claims and justifications. For instance, in 1966, Baumol and Bowen's *Performing Arts: The Economic Dilemma* stressed that the arts could never be self-supporting as they are labor intensive and cannot achieve economies of scale. A production of Man of La Mancha, so their argument goes, will always need the same amount of actors that cannot be replaced by any machine. A string quartet will always need four players, and

so on. Services with these characteristics have little capacity to increase in productivity over time, as Netzer (1978) explains:

> When productivity in the rest of the economy is rising, then wage rates in all sectors of the economy must rise, including those in labor intensive sectors unable to register productivity gains. Raising wages in the absence of productivity increases, raise the cost of production, and the price at which they are sold. (page 78)

From this cost-disease thesis, the subsequent policy is that the arts will always need government support to survive.

Baumol and Bowen's was only the first of many studies that have been published with the purpose of justifying public and private funding. Grampp (1989) compiles seven of the most frequent and strongest justifications that have emerged out of these studies.

1) The arts are Public Goods. Their benefits are extensive, non-excludable, and difficult to price.
2) The arts yield positive externalities.
3) The arts are Merit Goods.
4) The demand for arts depends on the supply. Without the arts being made available to people, they never would know its value. Hence, to be available in proper amounts, it must be subsidized.
5) The arts should be available to everyone for reasons of equity as well as efficiency.
6) The arts are labor intensive (the cost-disease thesis).
7) The stock of arts must be maintained and as maintaining it is not a profitable activity, there must be a subsidy.

Towse (1994) adds three more justifications:

8) Option demand. People who cannot or do not at present participate in the arts by buying tickets, nevertheless are willing to pay via taxes to keep the

arts going. The cultural good is available just in case
the agent wants to use it at some time.

9) Future generations. There are benefits derived from
the arts and legacy the present generation passes on
to future generations who are assumed to have the
same tastes and preferences and technological possi-
bilities as the present generation.

10) National prestige. Subsidies should be directed to
the most prestigious personalities and to the institu-
tions that bring pride and attraction to one's country.

Faulty Justifications?

Netzer (1978) explains that there may be some "hazards" of
subsidy programs. Specifically, he claims that subsidizing any
good that may be slightly market oriented may increase the
incomes of those involved in its production or lower prices to
current consumers without encouraging changes in quantity and
quality of the product or service. Netzer points out that the
argument that is provided the most to justify government
intervention, the cost-disease thesis, is misused. If we were to
actually follow the cost disease thesis, subsidies should mainly be
directed to operating and maintenance costs. But in reality,
subsidy policies stay away from funding specific arts events or
hiring of labor. Grampp and Marquis also point out that this
"thesis" is not as strong as previously thought. First of all, the
productivity of labor in the arts does increase every time a concert
is recorded and sold in tapes or CDs. In fact, Frank and Cook
(1995) argue that the market overestimates the productivity of
some of its members, especially artists, as technology has made
them more attractive. A quartet can increase its productivity by
performing more than once in the same day or week. In the for-
profit performing arts, for instance, the trend has shifted from
multi-sets many-actors presentations to simple settings and one

actor shows. As Grampp points out, Baumol and Bowen assume that the value of the arts is greater than that which the market places on them. Even if this is true, there is nothing in economics that says that an increase in relative costs and price is itself a condition that calls for a subsidy. The fact that the highest price a person is willing to pay to buy a good does not cover the minimum cost of this good does not imply market failure.

Grampp finds no evidence brought forward to show that subsidizing the arts would yield any of the benefits a so called public good would, or that subsidizing these goods would provide more pleasure than subsidizing anything else. If there is enough proof as to the willingness of consumers to pay for the arts through their taxes, then we could say that society in general creates the convention that this good should be "public." Many studies have tried to prove just that. Grampp reports how a Harris Poll was promoted as giving strong evidence that a considerable portion of the public was prepared to lay out considerable amounts of money to support the arts on the ground of their public benefits. Actually, the poll tells us that 38% of the respondents favored the cultural subsidies while 34% did not, 14% were not sure and 14% said "it depends." Grampp reminds us that the fact that 100% of the population feels that the arts is a worthy enterprise is no assurance that they will all pay for it. We would still face the free-rider problem.

The Merit Good justification is also weak. It implies that although people know what is better for themselves, they are better off if someone tells them what to do with their preferences. The argument suggests that whatever has an impact on the agent must not necessarily have his or her consent, and that there may be other agents intervening in his or her life to decide if it should be done.

If in reality supply creates its own demand, as the argument claims, subsidies should be directed to every single sector of the economy. Every time a new product is introduced in the market, there is uncertainty and risk for both producers and

consumers. To reduce this lack of information or asymmetry of information, a privately funded advertising and marketing campaign is planned. When Disney wants to promote a new CD, they often put together marketing campaigns like a "1-800" number that lets the consumers hear this CD first before they buy it. But this assumption is applied differently to the arts and we are led to believe that ignorance alone keeps people from going to the opera. Museums in Italy must be subsidized, so the argument goes, since the Italians have not had time in the last 200 years to get acquainted with these institutions.

Another argument tells us that the arts experience decreasing average costs. The fixed costs they have to pay may be quite high, but their variable costs are likely to be constant. Arts organizations can easily increase prices and reduce the amount of people they serve and still cover their total costs. But then government enters into the picture and imposes the condition or follows the convention that to maximize society's satisfaction, arts organizations need to charge a price so low that it may attract as many clients as possible even if it does not cover operating costs. Any deficit is covered by the government.

Even if all these assumptions are valid, most of the time the subsidy goes to the producers, leaving unexamined the needs of the demand side. The reality is that even giving subsidy to the producers only provides an incentive for museums to grow faster than needed, and operas to be more luxurious than demanded. On the other hand, giving subsidies to the consumers arises questions on efficient distribution strategies and fair eligibility criteria (Peacock, 1992).

By the late 1970s and 1980s, it became clear that even with a cunning use of the numbers, survey after survey was indicating that the arts were not becoming more democratic but remained elitist. Something needed to be done to justify continuous funding of the arts. Many arts council administrators, Marquis (1995) tells us, made it fashionable to commission college professors to

conduct economic impact studies at the regional and state levels. Almost every state, county, and city in America published its own study that described how the arts' spending shaped the economy by creating artists' colonies that changed the image or ambiance of the community. The emphasis of the studies shifted from using words like "subsidy" and "grassroots" to using terms such as "investment" and "image". The goal was now to highlight the impact investing in the arts had on economic development. The studies refrained from any discussion of the opportunity costs associated with these projects or any use of sound empirical techniques that would support the claim that arts attract businesses (Seaman, 1987). But as Radich and Foss (1987) explain, these impact studies became quite successful and popular due to the language they used. For the first time, arts managers were seriously talking about employment, revenues, deficits, profits, and economic impact. They were using the language business people and bureaucrats understand and presenting the results in a fashion that would bring the greatest possible effects to the arts community. But this very political overtone prevents them from having policy value (Cwi, 1987). They shed no light on the need for financial support of existing activities and provide no information regarding the need to increase the supply of arts.

As Table 2.1 shows, the 1990s brought back a wave of decentralization in the U.S. Congress that reduced Federal funding of the arts and emphasized regional coalitions of nonprofit artist, regional leaders and city officials.

Coalitions Among Nonprofit Organizations, Government and the Private Sector

In America, nonprofit organizations were first defined as firms engaging in activities spread through all the other sectors of the economy. The 1969 Tax Reform Act and the increasing number of foundations providing funds and resources to such organizations

Table 2.1 Most Recent Appropriations for Arts Related Federal Government Entities in the Unites States (in millions of $)

Cultural Agency	95-95	95-96	96-97	97-98
National Endowment for the Arts	170.23	162.36	99.47	99.49
National Endowment for the Humanities	177.50	172.04	111.34	110.00
Smithsonian	302.35	313.85	317.19	334.56
Kennedy Center	20.63	19.31	19.88	20.30
National Gallery of Fine Arts	54.74	57.33	53.90	55.84
Commission of Fine Arts	0.81	0.83	0.87	0.91
Institute of American Indian and Alaskan Native Culture and Arts Development	12.56	11.21	5.50	3.00
Holocaust Memorial Council	21.68	26.61	29.70	31.70
Total	760.50	763.54	637.85	655.80

Source: Department of the Interior and Related Agencies Appropriations Acts (1994-1997).

made it necessary to commission studies to determine in more precise terms the quantitative dimensions of nonprofit activity. As Hall (1992) explains, these studies emphasized the distinctions between nonprofit and other institutions, and avoided exploring the ways in which they overlapped and influenced one another. Scholars promoted the idea that certain kinds of activities were intrinsically nonprofit in character. Hansmann (1987) for example, explains the emergence and permanence of the nonprofit form by assuming that nonprofit organizations develop in response to a particular form of market failure called contract failure. This contract failure results because sellers have more information than buyers about product quality. As Pignataro (1994) explains, in the cultural sector, this asymmetry of information is present in both ends: the conductor or the players of an orchestra will know better than their audience whether their concert has been thoroughly prepared, the amount effort they put in, and so on. The problem is that, actually, the producers cannot be sure about the quality of their performance or whether the audience will like the concert. This uncertainty will only be resolved (if ever) after the concert is consumed.[1] In this situation, Hansmann (1987, 1981) postulates, a for-profit firm has both the incentive and the opportunity to take advantage of customers by providing less service to them than was promised and paid for. Chasse (1995), DiMaggio (1990) and Hansmann (1987) assumed that the only reason a nonprofit will arise in sectors like the arts is due to their ability to provide assurance that what is produced is what the buyers want. Another peculiarity of nonprofit firms is, as Hansmann (1987) describes, that they cannot distribute potential surpluses or profits earned from decreasing service, lowering quality or by increasing prices (nondistribution constraint). In this framework, donations become a crucial element in the analysis of the structure of the firm. For instance, the live-performing arts are commonly characterized by fixed costs that are high relative to marginal costs, and by a demand that is relatively small (Hansmann, 1981). To survive

without subsidy, the Arts organization must engage in price discrimination. However, the opportunities for doing so through ticket pricing are limited and patrons and their donations become a system of voluntary price discrimination. Hansmann (1981) postulates that nonprofit performing arts organizations set price below revenue maximizing levels to encourage patrons to make tax deductible contributions, which in turn could increase organization revenues. The patrons incur lower overall costs because of the tax-deductible donations while "paying" more than they would have paid without the donation.

Widening the conceptual gap between the nonprofit and the private sector, Hansmann (1987) proposes that assuming cost minimization in the nonprofit sector neglects the fact that these firms have little incentive to behave in such a way due to the absence of ownership claims to residual or earnings or surpluses. More importantly, it is commonly assumed that the goals and incentives of these forms of organization are different as well. In general, the literature assumes that nonprofit organizations, unlike private firms, maximize either service quality and the prestige of the firm or the dissemination of their Art among the widest audience (DiMaggio, 1987; Hansmann, 1987, 1981; Gapinski, 1985). One of the main flaws of these assumptions is that the concepts that conform them have never been defined. For instance, let us assume for a moment that nonprofit organizations do maximize the "quality" of the service they provide. Now the problem becomes trying to define what is meant by quality of cultural goods. And once the term quality is defined, how do we establish if there is any objectively identifiable quality in a work of art? As Pignataro (1994) points out, it is impossible to disentangle what is simply the technical ability of an artist from his creativeness. This difficulty is underlined by the fact that arts critics often express different opinions of an artist's work even from a technical point of view. Cameron (1995), Smith and Smith (1986), and Taylor (1974) have tried to assess the impact of arts

critics on performance and ticket sales, but no one has yet formulated a formal model of either their nature or effects. Quality then becomes a matter of purely subjective appreciation that is not perfectly correlated between consumers, as Pignataro puts it. Now let us assume that nonprofit arts organizations' goal is to spread culture to as broad a segment of the population as possible. Hansmann (1981) postulates that output or attendance maximizing organizations would use their funds to undertake activities that increase attendance. The firm will choose that level of quality that maximizes net revenues and use those extra revenues to reduce some ticket prices and attract larger and more diverse audiences. This assumption requires cost minimization for a given quality level -which they already said is not a characteristic of the nonprofit sector. The interesting conclusion derived from this assumption is that the firm has the incentive to choose a level that approaches the optimal level of quality in cases where the average and marginal audience members value quality differently since donations reflect primarily the preferences of that extra (marginal) audience member. DiMaggio (1987) presents an even more complex view of the objective functions of nonprofit cultural institutions. He has a more cynical view of the nonprofit Arts sector and "suspects" that these organizations are after a very specific audience type while (or because) their managers are looking for personal recognition. In more formal terms, he claims that besides maximizing quality or output, arts organizations may have as their goal:

- the survival of the firm;
- budget maximization; and
- maximizing the rewards of arts managers.

These goals may be present at the same time by different members of the organization (patrons, artistic director, administrative director) or at different times (as the organization

grows, different "mission statements" may be formulated). The researcher trying to formulate a model of the behavior of a cultural institution or industry must establish what combination of these goals is followed or if there is a modal objective function.[2] DiMaggio postulates that factors like size of the firm, relative influence of the different members of the firm, and type of sponsorship determine the heterogeneity of the objective functions. In fact, Hansmann (1980) points out, nonprofit organizations are fundamentally about juggling the interests of a diverse group of constituents. The management task in a nonprofit organization is not to maximize the satisfaction of any one group but to minimize the dissatisfaction of all the groups.

All these arguments provide the foundation for the erroneous idea that certain activities only belong to the nonprofit sector. They seem to forget that by 1945 only about 30% of American hospitals were nonprofit, as the Historical Statistics of the United States indicates. As DiMaggio (1986) shows, most performing arts organizations were for-profit until the late 19th century and libraries were overwhelmingly proprietary until the 1960s. In New Haven, Connecticut for example, there were no nonprofit theaters until the 1960s - and their rise is linked to the rise of large-scale corporate, foundation, and national arts and humanities endowment patronage. Today, hospital and library services, and cultural activities are provided by privately-run firms, the government and nonprofit organizations. They are all working to capture the same market by providing the best service in the industry.

Technology has made defining nonprofit organizations even harder without emphasizing its links to the other sectors of the economy. A 1992 " Survey of Public Participation in the Arts" reported that 65% of adult Americans watched or listened to the arts primarily produced by nonprofit arts organizations through the privately-run media. Ignoring the strong links between the sectors prevents us from analyzing the many issues nonprofit

organizations will face in the future in order to survive: should the nonprofit sector limit itself to the production of arts and leave its distribution to another sector of the economy? And if we agree on that, will nonprofit artistic visionaries agree that Pavarotti lip-synching an aria is "art"? Or that a Beethoven concert in a blockbuster film is still "sublime"?

While Salamon's (1987) research does not consider how all these sector compete with one another, it did open the doors to exploring the nonprofit sectors in terms of its relationship with the other sectors of the economy. This corporatist perspective examines coalitions between elected government, local profits and nonprofit businesses and assume that this interaction determines the shape and results of local urban development policies (Bovaird, 1992). As Salamon points out, the advantages of this interaction are multifold.

- The government is in the position to generate a more reliable stream of resources, set priorities on the basis of democratic political processes, and improve the quality of service by instituting quality-control standards.
- Nonprofit organizations can personalize the provision of services, operate on a smaller scale than government bureaucracies, reduce the scale of public institutions needed, adjust service to the needs of clients rather than to the structure of government agencies, and permit a degree of competition among service providers.
- The private sector enters into the equation to enhance the competitive edge needed to guide further investment strategies and provide permanent sources of jobs and income.

Following this corporatist approach, Zukin (1995) argues that the only contribution culture can make to redevelopment processes is to help re-build the image of a blighted community. Cultural

institutions establish a competitive advantage over other cities for attracting new businesses and corporate elites. Culture then defines and shapes the symbolic economy that encompasses everything from production of symbols to the creation of the public space where most social and economic activities take place. Once nonprofit organizations or a historic preservation legislation has changed the image of a blighted community, Zukin explains, the private sector, searching for a solid investment opportunity, will start looking at the possibility of investing in the area, providing full-time permanent employment and improving the infrastructure of the city. Zukin argues that most of these arts-led redevelopment programs follow very closely a similar strategy: they almost always start with artists interested in redeveloping a city and academians writing technical articles on the most efficient ways to improve the social, economic and architectural structure of the area. The government provides assurance that the public space (street lighting, sidewalks, police protection and general public works) is re-created by the public. Once the arts-led redevelopment process has matured and the private sector has shown interest in it, the academic articles become newspaper and magazine features that go hand in hand with books that show with colorful pictures the beauty and potential of the once blighted city. Very soon nonprofit arts organizations and the original residents of the community are completely displaced by for-profit firms and more sophisticated residents.

Coalitions of this type are commonly found in successful arts-led redevelopment processes. On the ruins of New York's 42nd Street at Broadway, for example, the Arquitectonica's project has emerged as a joint effort among the government, arts organizations and private firms. The state of New York condemned the entire 13-acre block and cleared the way for eviction of more than 400 businesses, many of them sex-related. Backed up by a strong public relations campaign, major companies have invested heavily in the area. Disney has brought the old New

Amsterdam back to its former glory, the old Lyric Theater is a part of the new Ford Center for the Performing Arts, and the 499-seat New Victory Theater reopened as a nonprofit youth-and-family theater. This is not the first attempt at revitalizing the area, but it is the first time when the local government decided to unite forces with the state government, local nonprofit agencies and private companies to find a common goal and design and implement a revitalization plan.

Historic Preservation and Development

Government support of the arts is perceived differently in Europe where public expenditure for cultural activities often takes the form of direct provision by means of state-owned arts institutions. In the United Kingdom in 1989-90, for example, almost two-thirds of the total funding on the Arts, Museum, Heritage and Galleries was direct funding to nationalized arts organizations (Towse, 1994). In 1988, the then West German government spent, in total, four times the amount the United States government allotted for the arts (Levy, 1997). In the United States in the 1990s, the National Endowment for the Arts has had to use most of its resources to lobby not for increased funding but for earning the right to keep its doors open.

But when it comes to Heritage, the laws guiding the preservation of historic buildings and monuments follow almost the same goals and mechanics in both the United States and Europe. The United States and most European countries have all passed laws and created government agencies whose main goal is to successfully preserve publicly and privately-owned historic monuments by providing technical and financial assistance. These government agencies help balance public funding with a myriad of obligations which private owners of listed buildings must meet. These preservation laws and legislation create an increased demand for preservation. As time passes by, there will be

historical additions and more buildings are coined as worthy of preservation and funds. Furthermore, the political nature of the process of determining what is "historic" promotes the constant re-definition of the concept of heritage and encourages rent-seeking. Benhamou (1996) describes how in France in the 1970s, new listings included original decor restaurants, cafés, shops and swimming pools. The cost of upkeep and restoration can be taxing as well since technological improvements can do very little in this sector. Even though productivity could be increased dramatically by changing the methods and materials used for restoration, this would change the very nature of the monument to be preserved. This situation, Benhamou claims, could be corrected by limiting new listings or by striking monuments from the list.

Of course, differences quickly arise between the European and the United States model of preservation. While there is a National Registry of Historic Buildings in the United States, each state has its own Preservation agency that ultimately makes the decision as to what building could be considered historic. In France, on the other hand, within the Ministry of Culture there is the *Sous-Direction des Monuments Historiques et des Sites* that has its own administrative staff and architects, and its central directives are implemented throughout the country by some 15 regional conservation authorities and a staff of inspectors. And while for Europeans, their heritage is a matter of national concern and pride, for the United States, preservation has a strong appeal because its emergence coincides with the rise of new urban politics, whose keywords are decentralization and community control. For Americans, historic preservation became both a goal of grassroots mobilization and a means of establishing their regional identity (Zukin, 1995).

As Benhamou (1996) explains, coalitions among all sectors of the economy are also formed to ensure the best preservation strategy. The government usually manages the preservation grants, oversees the restoration work by private

contractors and hires historians, nonprofit arts organizations, urban developers, designers and architects to ensure that the historic and artistic value of the buildings is preserved. Private-owners of historic buildings happily cooperate with the local officials since they realize that they can cash in on the increased value of their property. Nonprofit arts organizations also cooperate by forming political or neighborhood organizations that ensure that the artistic and historical value of the monuments and process is preserved.

Techniques of Arts-led Redevelopment

A cultural coalition has decided to use their artistic resources and their historical buildings and monuments to change the image of a city and promote a redevelopment plan. In general, they can design three strategies: sponsorship, marketing the arts or cultural tourism.

Sponsorship

Approximately $6.8 billion in corporate funds is available to sponsor charitable events, according to an estimate by the International Events Group, a firm that tracks corporate sponsorships (Brewer, 1998).[3] The cultural coalition going after those funds could embark on a marketing campaign to attract sponsors and patrons (ideally from outside the community), and assure a transfer of the financial burden from the government to private agents. Both corporations and nonprofit organizations benefit from this transfer. Corporate donations could be considered an investment on corporate image and favorable reputation. The corporation benefits from the advertising and association with the event and the nonprofit. Individual sponsorship, on the other hand, represents a case of price discrimination and could be affected from everything to personal satisfaction to the level of recognition

received as a consequence of the donation. The nonprofit organization benefits by receiving a package of cash and in-kind gifts that can cover substantial portions of an event's budget.

The sponsorship process needs to start early in order for corporations to work the funding into their annual budget and for cultural coalitions to program events that can make the arts more understandable. Fundraisers have realized that to make opera or ballet fundable they need to bring the artists, composers and choreographers down to the level of the corporate patrons by providing simple yet instructional demonstration of exactly what it is the organization does, how to appreciate it better and most importantly, how to understand it.

One of the major limitations of this technique is that corporations and individual sponsorship are, as Hansmann (1986) shows, highly sensitive to the price of giving. Tax incentives for sponsorship take the form of indirect subsidies, that is, the government (federal in the most part) ends up paying for the entire process. Increasing contributions for the arts became more difficult in the United States with the 1986 Tax Reform Act. The tax rules changes that affected charitable contributions the most include: reduction of top marginal tax rate from 50% to 28% which makes charitable contributions less valuable as tax shelters, and the elimination of charitable contribution deductions for nonitemizers.

Marketing the Arts

The coalition could think of merchandising their cultural activities as an appealing alternative to regular entertainment. Promoting cultural activities as regular products requires an extensive knowledge of the market, their tastes, and their dislikes (see discussion of cultural demand studies in the next chapter). But most importantly, it forces us to think about what marketing is all about. In a regular marketing campaign, we could say that if every

orchestra wanted to increase their amount of customers, they could either play the music that a larger market segments wants to hear or reduce ticket prices. But this could come in conflict with the nature of nonprofit arts organizations that emerge as a way to prevent the demands of an "uneducated, uncultured market" from dictating what the arts is all about. As Harding (1998) explains, consumers of nonprofit arts organizations (donors, end-users, etc.) need to be assured that the particular value that leads them to patronize a nonprofit is being honored. Hence for nonprofit organizations, credibility is the prerequisite for continued existence and the equivalent of a business' bottom line. In essence, just as a business must make a profit to continue its existence, a nonprofit must deliver the programs and services in a trustworthy manner to its various constituents. A successful marketing strategy must also account for the fact that within the market of people who attend orchestra presentations, there are more popular pieces that people have learned to appreciate and love or have simply grown tired of. And unlike most goods, decreasing the price of a concert only reduces the perceived value of the event and discourages arts lovers from attending the event.[4]

A more successful marketing in the nonprofit arts sector may take the form of a massive arts education campaign that creates the acquired taste for arts from early childhood, forms educated cultural citizens and ensures future consumers (see discussion of cultural demand studies).

Cultural Tourism

During the 1970s, exploiting cultural resources as major tourist attractions became a major trend among city officials. Today cultural tourism is a growing segment of the tourism industry and a preferred alternative among cultural coalitions. This strategy is promoted as a tool to promote economic development drawing upon resources available in virtually every community and without

ant

significant infrastructure outlays. Brochures on heritage tourism claim that creating a new job in heritage tourism costs only one-eighth that of creating a new manufacturing job. It is reasoned. Wong (1996) explains, that tourism will result in an improved infrastructure and will enhance local government revenue as the property tax base expands through development. It is also argued that tourism can create a large number of seasonal jobs in a short period of time for little cost. And most importantly, a large portion of the expenditure on redeveloping the city would come from sales taxes paid by guests and visitors. These arguments were strong enough for the World Bank and the Getty Trust to form a coalition to sustain cultural heritage in developing countries. The agreement, signed in November 1997, seeks to support access to, conservation of, and education about cultural heritage. The coalition will identify specific operations and projects where the two organizations can collaborate to protect and sustain cultural heritage, and will jointly undertake pilot projects.

Cultural tourism models have already been designed and implemented in Australia and several cities in the United States. These models emphasize:

- the promotion of major arts festivals by development of product and packaging; identification of niche markets and"branding" identity on the internet;
- developing interpretative tourism and sophisticated tourism itineraries;
- relevant data on cultural tourism and heritage have been collected by academians that attend conferences and lecture on seminars on the subject;
- usage of historic sites as a venue for other artistic activities like theater productions or concerts; and
- cultural groups often travel to different cities to present programs. Similarly, government officials often travel to other areas to promote tourism and conventions in their







Valuation Service helps the nonprofit define the assets of the event and help them bring in the most revenue. The organization also holds a national conference and regional conferences for companies and nonprofit organizations.
[4] See Appendix B.
[5] See Appendix A for studies on Marketing Cultural Tourism.

3 Evaluating Cultural Coalitions: Measuring the Arts

Introduction

Today government officials are encouraged to seriously consider investments in cultural activities as a valid alternative to solving particular economic development problems. Even though economists do not advocate the use of impact data as an important tool for defining public policy towards arts and development, governments are doing so. It is then important that the most appropriate theoretical formulation for these studies is determined and that their empirical limitations are understood.

Goals of Cultural Strategies

Before evaluating a redevelopment process initiated by cultural activities, the relationship between expenditure on cultural activities and some measurement of economic development needs to be clarified. As Peacock (1995) explains, public statements by cultural coalitions can be of the vaguest kind since they themselves do not have a clear picture of how to measure cultural inputs and outputs, and have an even more limited knowledge of how to measure changes in the quality of living of a city. This situation makes it difficult for economists or urban planners to evaluate the effectiveness of a redevelopment plan. For instance, since the late 1970s Miami Beach city officials have attempted to revitalize the city. While their goal was clear, the routes taken were plentiful and at times conflicted with each other. As we will discuss later, even when the city had chosen preservation as a tool for development,

their implementation programs failed to recognize what steps needed to be taken to go from a preservation movement to economic development. This confusion was exacerbated by different sectors of the city, that while trying to revitalize the area, were working independently and sometimes against each other.

Once the coalition has established a clear well-defined strategy, a method of evaluation that can help identify its strengths and limitations should be selected. Each case will require for the members of the coalition to define what "cultural activities" mean and how cultural inputs and outputs are going to be measured. In addition, the development goals are to be clearly stated in terms of how a particular industry will be affected by the cultural strategy and how it will generate a measurable variable of economic development (income, revenue, job creation). Traditionally, cultural coalitions have chosen a limited number of evaluation techniques. In the next few sections, we will discuss the assumptions behind some of these techniques, explain their main advantages and propose ways to improve them.

Input-Output Model

The Input-Output (I-O) Model is commonly used to assess the impact of an economic activity on the rest of the sectors of the economy. It is constructed from observed data for a particular economic area and is appealing for its emphasis on the interconnection among industries. The economic activity in the area is divided into a number of production sectors and the necessary data to build their model are the flows of products from each of the sectors as a producer to each of the sectors as a consumer. In any economic region there are sales to consumers who are exogenous to the industrial sector. Households, government and the external sector enter, for example, in this group. The demands of these exogenous units are referred as *final demand,* and are represented by goods to be used as such (i.e., final goods) and not to be used as inputs (i.e., intermediate goods). The

magnitudes of the inter-industry flows can be recorded in a two-entry table, with the purchase of recorded inputs down the rows and the sales of output listed across the columns. These figures are the core of input-output analysis. One fundamental assumption of this approach is that these inter-industry flows depend entirely and exclusively on the total output of the destination sector. The input-output model assumes that to produce one unit of output, the sector has to purchase inputs from other sectors in a given proportion. This proportion is called the technical coefficient. It expresses a fixed or unchanging relationship between a sector's output and input requirements. Therefore, when an exogenous demand for a product exists, to produce this unit, the sector triggers a multiplier effect that stimulates the whole production sector. Moreover, to produce this unit of output firms buy labor. In this process, households earn incomes in payment for their labor inputs to production processes. This income, in turn, is spent in consumption, and generates more production, income and so on. In other words, households' consumption depends on the output of each of the sectors and in turn affects the new levels of output.

One of the most important uses of the information gathered from input-output tables is the assessment of the impact of changes in the final demand on the rest of the economy (e.g., how would a $2.5 million government funded performing arts center impact the economy). Several summary measures can be derived from the input-output tables and are often calculated in these impact studies. These are what are known as input-output multipliers. Three of the most frequently used types of multipliers are those that estimate the effect of changes in exogenous demand on total and sectoral output of the economy, income earned by households and employment that is expected to be generated because of the increased output.

The input-output model is but one of the many methodologies used in the field to assess such impacts. For instance, the literature pays close attention to the aggregate Keynesian multipliers. These multipliers are subsumed in the discussion of another model deriving multipliers, namely the economic base multipliers. The multipliers are, however,

commonly dismissed on the ground that they have less merit than input-output multipliers. In fact, economic base models have had a long and irregular history. They have never been quite academically respected and the revival of research on measuring the economic base in the 1970s was unexpected, as Richardson (1985) points out. Both methods have a special appeal: they offer a clear link from the national economy to the region within a standard macro-econometric (income determination) framework.

Seaman (1987) claims that most impact studies have identified only one of the components of the impact of cultural organizations in the economy. They tend to ignore concepts like opportunity cost, marginal versus total measurements, allocation of resources, distribution of goods and the leakage. Determining this leakage is crucial as the smaller they are, the bigger the multiplier. Seaman points out that very few studies have dedicated time to study what he considers the real role of arts: the development of Human Capital and the distribution of intra-regional economic activity.

Besides the myriad of studies commissioned by local arts agencies, it is worth mentioning two major arts impact studies that used the input-output model. The Lynch study (1993) conducted a nationwide survey of 32 communities' arts institutions for three years. Its main objective was to document the experience of a cross-section of American communities and demonstrate what they have gained from investing in the arts. The study used an open input-output model[1] to estimate the impact these arts organizations have on their communities, and presented results that constitute the first comprehensive attempt at measuring the amount of cultural workers and their impact on the economy. The results estimated that total expenditure on arts activities in the United States for that period was $36.8 billion, creating 1.3 million full-time jobs. Similarly, the Port Authority of New York-New Jersey conducted in 1992 is the most comprehensive report on tourism and the arts in the United States (Lynch, 1993). They used databases like the Air Passenger's Survey, Travel Intelligence System and the In-Flight Survey of International Air Travelers to assess this impact. Their

results are considered the most accurate and significant in the field since the study employed a very strict and conservative methodology, conducted comprehensive surveys to evaluate tourist behavior, and counted with the financial support of the public and private sector (Lynch, 1993). The results of this study clearly determine the importance of the for-profit arts sector in the economy of the New York-New Jersey in stimulating not only tourism but also in attracting other more conventional industries into the city.

Case Study: Dade County's Nonprofit Arts Organizations

During the Summer of 1995, I collaborated in an impact study that utilized the multiplier analysis. Its main goal was to determine the impact of Florida's Dade County nonprofit arts organizations on the local economy (Carvajal et.al., 1995). The methodology of this study will help us understand more clearly the virtues and flaws of this approach.

Data The research team, commissioned by the Dade County Affairs Council, obtained figures on total expenditure by nonprofit arts organizations receiving grants from the Dade Cultural Affairs County. The exact questions asked in the Survey are found in Appendix C. In general, the survey asked for:

1) sources of revenue for the 1994-1995 fiscal year;
2) current expenditures;
3) capital expenditure and sources of funding;
4) work force; and
5) attendance.

These organizations were divided into "Cultural Organizations" (i.e., organizations that carry events more than once a year) and "Festivals" (i.e., organizations that carry an event once a year) as defined by the Dade Cultural Affairs Council. From its early start, the research team faced problems collecting data from

the arts organizations which made it necessary for them to look for ways to solve sample bias. For instance, out of the 750 organizations that receive support of the Dade Cultural Affairs Council, 140 (19%) fully answered the survey which produces a substantial non-response bias. Since this study was sponsored by the Dade Cultural Affairs Council, there was also the tendency by arts organizations to alter some of the numbers to indicate compliance with the requisites of the Council.[2] When asked for the price for their events, most organizations did not provide this information or simply wrote down that all their events were free. But at the same time, when asked for the revenue coming from "admissions" they did provide a figure. All of these inconsistencies should be taken into consideration when interpreting the results of this study.

As Jessen (1978) recommends, these sample-bias could be improved or eliminated by actually designing better or more clever surveys, re-interviewing, checking for consistency within the survey, and double sampling.[3] Cwi (1987) discusses how response bias has been dealt with in the literature. He explains that one approach is to simply ignore the problem. Other studies assume, Cwi explains, that since the sample was, for example, one third of the population, the aggregate results can be multiplied by three. This solution may lead to overestimation. Other researchers assume that only small organizations would have no incentives to answer these surveys and decide to assign the non respondent organizations a "small budget" figure. This number is defined differently according to the state. Oregon's 1981 study assumed that a small organization has a budget of $5,000.00. Other studies are more candid and admit, like in the case of Iowa's 1985 report, that the process may have been led to under or overstatement of economic activity in certain categories depending on the reliability of the sample used (Cwi, 1987). Cwi also reports that many arts impact studies throughout the nation derive results out of very few respondents. Furthermore, most of them aggregate several categories of arts activities since disaggregated data are not available. The cases of Mississippi, Oregon and Colorado are

mentioned as examples of how the researchers use at most 29% of all the arts organizations to conduct these studies. The researcher faces apathy from the arts community that feels that filling out these questionnaires are complicated or a waste of time. There is also the case of very small organizations not trusting the intrusion of businesses and politicians in their affairs. They feel that their sponsorship could interfere with their creative decision process.

For the interpretation of the 1995 Dade County's Cultural Affairs survey's results, the errors will be assumed to be random and non-systematic. There was no explicit effort to get more involvement or responses from a certain type of art organization than from any of the others. For instance, out of the 140 organizations that responded, 51 were defined by the Cultural Affairs Council as Large Size organizations (annual budgets larger than $250,000); 45 Medium Size organization (annual budgets larger than $50,000); and 44 were Small Size (annual budgets less than $50,000.) Furthermore, if one looks at the list of participants of this survey, it could be said that most arts categories (e.g., theater and music) were represented (see Appendix C). To state the boundaries of the study in a more conservative fashion, as Cwi (1987) recommends, we will say that the study estimated the impact 140 nonprofit arts organizations in Dade County have on the local economy.

Methodology of the study After collecting the data from the 140 arts organizations, the next step for calculating the impact cultural organizations have on the local economy should have been acquiring an I-O table tailored to Dade County. The Carvajal research team could have acquired tables such as the one the U.S. Department of Commerce offers, REM II. There are other versions like RIMS II used, for example, by the Greater Miami Chamber of Commerce, and IMPLAN PRO that some private consulting firms use for their own studies. The cost of these tables ranges from $500 to $1500, which placed a budgetary limitation for the Cultural Affairs Council. Another possibility is using the input-output coefficients and multipliers the Beacon Council provides every year

for free. They run their own table with 538 industrial, governmental and consumer sectors of the regional economy. Their results reflect the purchasing factor of the county regional economy by indicating what share of a product consumed in the region is actually produced within the region. These results are based on data from the Bureau of Labor Statistics, regional commodity flow surveys, and the U.S. Commerce Department export statistics. However, the Beacon's input-output matrix table does not consider the arts an industrial sector and aggregates it into the "service column". Yet another possibility for the Carvajal research team was constructing their own input-output table that included the arts sector of Dade County.

The Carvajal research team decided not to follow this approach and instead used the methodology used in most impact studies sponsored and conducted by small to medium arts agencies: they borrowed the multiplier figure from some other similar study and applied it to their study. In this case they used the multipliers obtained by Lynch (1993). The study specifies the economic linkages of these organizations and the local economy in terms of full time jobs, personal income, total expenditures and capital expenditures. Cwi (1977) points out that using the expenditure side provides more conservative and accurate results as the expenditure information is obtained from the organizations themselves, and likely constitutes a more accurate first round expenditure estimate. On the other end, the paid employment that is reported underestimates the human resources consumed in arts activities because of the presence of a large pool of unpaid labor. There are many disadvantages of just borrowing these multipliers from other previous studies, but the most significant is that it goes against the very virtues of the input-output model: the researcher is not acknowledging and for that matter calculating the relationships between the nonprofit arts sector and the other sectors of the economy. However, as it has been fully discussed in the previous sections, to understand the nature of these studies we have to remember their objectives: arts agencies are trying to find arguments that could be appealing to both business people and

politicians and useful to their lobbying efforts. And the way they achieve this goal is by multiplying, if you will, the expenditures made by nonprofit arts organizations. The rationale and the economic assumptions and methodology behind it are not the issue here.

The coefficients and multipliers obtained by Lynch's study were used for the Carvajal study to estimate the impact for the different linkages as well as to what proportion of the impact stays in the County.

Results The results derived by Carvajal et. al. and published by the Dade County Cultural Council are explained below. Table 3.1 shows the results of applying multipliers to the different figures obtained from the survey. The 140 survey respondents were divided into two groups: Festival Organizations (n=31) and Cultural Organizations (n=109).

The total expenditure on goods and services other than capital expenditures for all these 140 organizations was calculated first and resulted in a figure of $112.5 million in expenditures for the 1994-95 fiscal year. This same figure was calculated separately for the two groups indicating that total expenditure for Cultural Organizations was $92.8 million and for Festival Organizations, $19.7 million. For all 140 organizations, the majority of the expenditures were allocated for personnel with full time salaried and part time employees accounting for $52.3 million. The Carvajal research team assumed that not all of this money stays in the community and that 80% of the money stays in the community and the rest leaks out ($74.22 million for Cultural and $15.79 million for Festivals stays in the County). This assumption was based on the proportion estimated by Lynch. Neither Lynch nor Carvajal provides any reason for this assumption. Besides, these proportions should not be a consideration for the input-output approach as any exogenous expenditure will affect the level of production in the community. Using this 80/20 proportion, the Carvajal team applies the multipliers to 80% of the expenditures of the Cultural and Festival Organizations.

Later the Carvajal team calculated the amount of capital expenditure by the cultural organizations (festivals did not report purchasing capital that year). They decided to separate the capital expenditures from the other expenditures as they assumed, without indicating in the study any rationale or justification, that capital improvement would have stronger effects on the local economy. The Carvajal team took figures obtained by the Beacon Council on the multiplier for Capital improvement in Dade County. Carvajal assumes that all the money that is spent on capital expenditure stayed within the county.

1) *Output multipliers.* The major linkage through which arts organizations affect the local economy is direct spending or expenditures by these organizations which directly increases income and output in the local economy. These expenditures have second round, or multiplier, effects as local businesses expand their operations. The initial effect of local expenditures by nonprofit organizations is calculated by applying to this figure the multipliers for this linkage as Lynch's input- output table derived (multiplier of 1.95). It was estimated that these organizations total contribution to output reaches $267 million (see Table 3.1).

2) *Employment.* The 140 arts organizations that answered the survey employ 1,623 individuals on a full time basis and 2,744 as part timers. The research team applied an employment multiplier of 1.95 as calculated by Lynch input-output coefficients which indicates the amount of money these salaries create in the economy (see table 3.2.) Carvajal et. al. estimates that these salaries increase output by $102 million. In Table 3.2, the amount of jobs generated outside the arts sector is calculated. The multiplier (32) is the numbers of jobs created per one million dollar expenditure on the associated good or service. The increase in total employment is of 3,548.

The amount of hours volunteer workers gave to the arts in 1994-95 was 286,261. Using figures by the Bureau of Labor Statistics, we know that the average wage for service workers in

Table 3.1 Economic Impact Study Dade County 1994-1995

	Revenue (million $)	Output Multipliers	Impact (in million $)
Total Cultural Organizations Revenue	74.22	1.95	144.74
Total Festival Revenue	15.79	1.95	30.8
(1) Total Revenue	90.02	1.95	175.54
(2) Capital Expenditure	33.92	2.7	91.6
Total Economic Impact (1+2)			$267.14

1994 was $11.62. Evaluating volunteer hours using an opportunity cost approach, we could say that firms save $3.3 million in wages that year.

3) *Income impact.* The final way in which to measure this impact using strict economic tools is with respect to income in Dade County. This is perhaps the most useful method since it is the only tool so far that directly relates the arts sector to enhanced living standards and economic welfare. Using Lynch's data, the multipliers for impact on income are estimated to be 0.8547. This is based on the assumption that all income did not stay in Dade County. This leaves us with an increase of $96 million in income in the County due to arts organizations.

4) *Tourism and the arts.* The Carvajal study focused solely on the economic impact of local spending by nonprofit arts organizations. It did not include the related spending by arts audiences (restaurants, hotels, parking), or by the for-profit sector (Sony Latin

**Table 3.2　Employment Generation. Dade County Nonprofit
Cultural Organizations, 1994-1995**

Total full time workers	1,623
Total part time workers	2,744
Number of volunteers workers	4,506
Total full time workers outside the arts sector	3,584
Volunteer hours	286,261

America, for example). The study could be expanded to reflect how these institutions attract visitors or tourists related industries like Lodging and Restaurants. Because cultural tourism is not usually defined as an industry, very little quantitative economic data are available from existing sources.　For this reason, to obtain estimators for the impact arts organizations have on tourism, data on expenditures and number of tourists for 1994-95 were obtained from the Greater Miami Chamber of Commerce. The methodology employed to calculate tourism expenditures and its impact follows reports by Van Tuyl (1996), Villamil (1996), and The Port Authority of New York and New Jersey (1992).[4] It will be assumed that out of the 9.1 million domestic and international tourists that the Greater Miami Chamber of Commerce reports, 12% were cultural tourists. They all spent $7.6 billion and out of this amount, $917 million was spent in entertainment and cultural events. Villamil uses the multiplier given by the Beacon Council for tourist expenditures in Dade County, 2.5. This figure leaves us with an economic impact of $2.3 million. Following Netzer (1978), it is important to understand that for the arts themselves to be a powerful attractive factor for tourist visitors, they must offer a concentration that is large, diverse and, quite unlike the arts,

available in a dozen other places. In cities like Miami, only negligible fractions of the visitors come largely because of the arts as such.

5) *Capital.* This study assumed that sources for capital expenditure are independent of their operating budget. This estimation of capital expenditure shows an investment of more that $33 million in the improvement and maintenance of arts capital with an impact of $91 million, using Villamil's multiplier for capital expenditures in Dade County. This figure would be an underestimation since only the impact capital bought today will have this year on the local economy is considered. This capital, of course, will have some impact for many years to come at a decreasing rate. In fact, the impact past expenditure on capital has on the economy today should be estimated as well.

Cost-Benefit Analysis

To estimate the impact arts organizations have in the economy, these studies must go beyond calculating benefits in terms of output and employment (which could be considered a cost as this sector takes away jobs from other industries) and deal with issues of quantifying all tangible and intangible benefits as well as assessing the most accurate value for opportunity costs. Frey and Eichenberger (1995) propose various methods for calculating the intangible benefits with which these arts organizations enrich the community:

1) by looking at the differences between the financial returns of art investment compared to the respective returns in financial assets;
2) by looking at the rental fees for art objects; and
3) by measuring the size of the marginal willingness to pay for art events.

Another method to evaluate cultural strategies is the Cost-Benefit analysis. In this technique the different cultural and non-cultural strategy alternatives are specified. One of these strategies is designated or treated as the base alternative and the various consequences of the others are expressed as differences from this base. The consequences are the positive and negative changes in well-being of everyone who is at all affected by each strategy in question. Whenever possible these changes in well being are calculated in money terms (Rothenberg, 1967; Gramlich, 1990). In comparing benefits among alternatives, differences in impact not only immediately but also in the future must be specified since redevelopment occurs as a flow over an extended period of time. To make the benefits from different alternatives at different times comparable, the researcher must convert all dated benefits and costs into present discounted values. This is of special relevance in the case of cultural strategies where not only the long-run social and cultural consequences should be taken into account, but also the possibility of such plan only working in the very short run.

This improved economic analysis consists of more than a listing of all the benefits and costs today and in the future. It estimates the externalities that arise from cultural strategies, any extra government revenue, and determines any consumer or producer surplus gained as a result of the strategy - how much do consumers and producers gain as a result of the strategy? This last step requires a previous one, calculating demand and supply functions of cultural activities. Both formulation and estimation of "cultural" functions can prove cumbersome due to a lack of solid theoretical tools and data availability.

Cultural Demand

Hendon (1981) explains that to estimate consumer surplus, one should first calculate the demand function for all the organizations receiving support from a particular government agency. One of the difficulties with such estimation is that the nature of the demand for culture puts it in conflict with neoclassical as well as new consumer

theory since we cannot explain the behavior of agents who consume cultural goods without the endogenization of tastes (Throsby, 1994). Perhaps one of its most intriguing characteristics is the fact that even when they are considered to be a luxury, and their income elasticity of demand is positive, cultural goods are price inelastic (Towse, 1992). Whithers (1979) shows that the reaction of arts audiences to a change in relative prices may be more limited than would be the case for many other products and activities. This is explained by observing that art appreciation itself is an acquired taste and skill, especially for "high" forms of arts like the ballet and symphony orchestras. If theater prices fall relative to other prices, for instance, individuals lacking those skills will not immediately turn to the arts. On the other hand, if relative prices rise, those who have such skills have developed them often at a considerable effort and cost and so do not discard their use.[5] The analysis becomes more intriguing if we consider that most high-culture performing arts take the nonprofit form of organization (Hansmann, 1981). Consequently, aspects that are absent in many demand studies, like information asymmetry and donations, measurement of quality and heterogeneity of goals should be included in the formulation of a model of demand for cultural goods.

In general, we would expect a demand function for attendance at artistic events organized by nonprofit firms to contain own price, price of substitute entertainment, price of goods complementary to attending a performance, consumer income, donations and quality characteristics of performance as explanatory variables.[6] This formulation seems to be standard, but what is usually neglected in the literature is a formal discussion of the functional form this equation should take (see Helburn and Gray, 1993; Svendsen, 1992; Gapinski 1985, 1984, 1981; Hendon, 1981). This incidence is not, however, exclusive to the field of cultural economics. As Deaton and Muellbauer (1980) point out, in nearly all demand studies consumer theory is used when convenient and ignored when inopportune. Most empirical work is carried out with very little reference to any consumer theory, Blaug (1992) explains,

and tends to emphasize estimation rather than verification. This explains why Luksetich and Lange (1995) justify the use of their form of the demand function for symphony orchestras in terms of having run different model specifications and getting similar results for most of them.

As Deaton and Muellbauer explain, the easy comprehensibility of the elasticity concept has led many economists to see the estimation of elasticities as the primary aim of empirical demand analysis. Researchers take for their estimations functional forms that easily allow them to calculate this elasticity without taking into consideration their theoretical foundations. For instance, if we take a look at the Stone's expenditure system described in Equation 3.1, we can interpret this as the demand equation in real expenditure and real prices which have been frequently estimated in the literature. The equation is based on a set of logarithmic commodity demand equations, income, and commodity prices p_k:

$$\log q_i = a + e_i \log (Y/P) + S_k e_{ik} \log (p_k/P) + u_i \qquad (3.1)$$

where p is a generalized price index, e_i is income elasticity, e_{ik} is a compensated price elasticity, Y is income, q is quantity demanded and u_1 is the error term.

In estimating this function, we must account for a number of restrictions including homogeneity of degree zero in prices (i.e., if total expenditure and prices are twice as high, the budget constraint is the same). The adding up restriction,[7] however, cannot be accommodated within the double log form. The only way this can happen is if income elasticity is 1 for all goods. The restrictions of homogeneity and symmetry (necessary to assume that preferences are consistent) are consistently rejected by the data. Another property of demand functions is negativity. This property assumes cost minimization, which in turn implies maximization. A positive price derivative or change can only occur if the good is inferior (as income increases, consumption of good "i" decreases,

as the negativity property must hold). But as it was discussed, as income increases, the consumption of cultural activities increases.

A better approach would take into consideration that cultural organizations provide goods that are quite heterogeneous. To estimate a demand function, one should first sort these organizations according to the one characteristic they do share. All cultural events, for instance, imply some outing for the audience. Some of these outings may require formal wear, some others may require some level of education, some may be conducted at an open space, others may require no capital expenditure, etc. All the attributes these outings have, along with its demographic, average price and attendance and the utilization of hedonic models for estimation could help determine the shape of the demand curve for a certain area throughout a particular period of time. Present in this demographic data should be some measure of how standard and style of living (not in terms of income) has changed from one year to the other. From these results, consumer surplus could be estimated.

Given a certain demand function form for a cultural firm, the next step is obtaining and operationalizing the appropriate data. While obtaining data for the own price variable is relatively easy, measuring price of substitutes and consumer income could prove cumbersome. Gapinski (1984), for instance, analyzes the demand function for the Royal Shakespearean Company (RSC) for the 1965-66 to 1980-81 seasons. Unsure of what variable to use to measure the effect of substitute goods, he used three forms for three different specifications:

1) price index for entertainment and recreational services;
2) average nominal price of admissions to cinemas in Great Britain; and
3) average nominal price of admissions to cinemas in Great Britain accounting for regional differences.

Gapinski reports coefficients for these substitute prices that are not statistically significant. By reviewing demographic reports

of theater goers, and interviewing these attendees, one realizes that this group of people would not consider "going to the movies" or any other common recreational service as a substitute for this "high" form of artistic expression. This group is mostly looking for a more challenging alternative to TV series and blockbuster movies. The price of subscription to the ballet, for instance, could more closely reflect the substitution effect for a Theater performance (see DiMaggio, 1990). Roughly, quality of performance could be measured by the amount of money spent on a certain production, who is appearing in the show, and what the critics have said in advance about the quality of the event.[8]

Luksetich and Lange (1995) had difficulties with the income variable they used to estimate their demand model for Symphony Concerts in various cities of the Unites States. They use the per capita household income in the home metropolitan area or country where these concerts take place. The results they obtained were not statistically significant in the models they estimated. Sometimes their results indicated that income was negatively related to attendance and to the average price of concerts. Given the nature of their audience, this could be explained by saying that "mean income" may not be a relevant measure of income and other points in the distribution may be more appropriate (e.g., percentage of population with incomes larger than $50,000). The authors used many alternatives but their results remained not statistically significant. They argue that any average market measure does not capture the effects of subscribers or attendees income on symphony demand. It is also important to consider that most cultural events at large performing centers in the United States are attended by tourists. Throsby (1994) suggests utilizing measurements of education as proxies for income, as it is commonly assumed that it is a significant determinant of income and it is positively correlated to arts enjoyment.

The issue of measurement of attendance is not as simple as it first seems. Some performing Arts events are perceived as luxury items that are associated with social status and the desire of the wealthy for conspicuous consumption, as Throsby (1994) puts it. It

may also be that social groups like students attend the events not necessarily because they can afford it, but because they tend to act as the social group they would aspire to belong in the future. Add to all this the fact that some performing Arts organizations let people in for free after a certain part of the show has been played (walk-ins) and offer complementary tickets for promotional, educational or egalitarian reasons.

Another problem is that most demand studies tend to take average prices as the own price explanator. This aggregation disregards the fact that most cultural institutions heavily discriminate against students, senior citizens, seating preferences, opening night events, and so on (Gapinski, 1984). Again, the issue of measurement of inputs and outputs in the arts is resolved by saying that the obvious biasedness these average prices may cause in the results is preferable than omitting them all together (see Reinhardt, 1975).

The grant variable should be included as high level of patronage implies that the quality level of the organization is up to the taste of the donor. This donor in turn provides the organization with money that keeps ticket prices low and helps attract attendance (see Hansmann, 1981). In Appendix B, we discuss the difficulties of operationalizing this variable.

Finally, nearly absent in the demand studies in the cultural economics field is the discussion of simultaneity. One of the standard apologies is that as profit motives are absent or attenuated or that since prices are determined by regulations or regulations-like processes, it may be possible to ignore simultaneity without a loss. One possible way to detect this problem is by conducting exogeneity tests like the Granger Causality test (see Greene, 1993). Luksetich and Lange (1995) did employ a simultaneous model to explain not only demand but also the production behavior of nonprofit symphony orchestras. Theirs is a six-equation model with attendance, average price charged, administrative expenses, orchestra quality, the number of concerts performed, and donations received from individuals simultaneously determined. Their exogenous variables include population age, income, advertisement

expenditure, development expenditure, number of guests in a concert, and a federal deduction dummy variable. The authors explain how lack of data had prevented them and many others in the past from running this type of models.

Demand studies would greatly benefit from information about the non-attenders, people whom direct cultural audience surveys can never reach As DiMaggio (1978) points out, this information ideally would let us know if individuals fail to attend the museum and the performing arts because of lack of interest, antipathy, inconvenience, prices, or arts training. We could also find out how many arts audiences are out there and what is the response of arts attendance to content. The answers to these questions go hand in hand with the question of what is the best marketing campaign for a nonprofit arts organization. If the non-attenders survey finds that people rather listen to Yanni than Mozart, should city symphonies completely change their annual programs and defeat the very reason they opened in the first place? DiMaggio points out that there may be another type of study that may be more consistent with the goals of the nonprofit: studying the process of socialization into the arts. How early does it begin? What attracts young children to the arts? How important is the family background of the children who attend the arts? How effective are arts education programs in helping create a taste for the arts?

Supply Functions

To calculate producer surplus, we must first define and estimate a supply function. One of the major difficulties in calculating a supply curve for nonprofit cultural organization is the nature of its inputs. Simply put, workers in this sector, contrary to standard labor economic assumptions, enjoy what they are doing. Unknown and struggling artists would gladly work for less than the average wage in their sector and for a low budget institution or firm with the hope of not only masterfully performing a piece they enjoy but also of being discovered by some bigger firm. When estimating the

production characteristics of these firms, the researcher has to deal with artists working long and strenuous hours for free and engaging in administrative duties as well. The difficulties of describing conditions in the complex arts occupation are deep-rooted. These conditions are so complex that it is necessary to use simplified concepts, such as limiting number of occupation categories (Horowitz, 1993). Deciding if the woman next door, who works nine to five at a factory and at night rehearses for the lead in *Medea*, is an artist or a factory worker still remains a conceptual dilemma in the literature. Another peculiarity of the arts labor market is its reliance on volunteers. For example, the impact of more than 286,000 hours of volunteers work[9] in Dade County's arts organization on the local economy should be studied more closely. It should be understood that without volunteers the nonprofit arts world, as structured, could not possibly accomplish what it does. Starting with board members, lawyers, economic and financial consultants and ending with ushers and office helpers, volunteers perform a myriad of tasks saving nonprofit money and time. Many organizations have actual volunteers coordinators on their staff to supervise large groups of regular volunteers. Furthermore, the image of retired couples volunteering at the local theater is incorrect. Meir (1990) and Day and Devlin (1996) report that more than forty percent of volunteers in the arts in the United States are "Caucasians" between the ages of 25 to 44. The Arts and Business Council of America prides itself of counting with a highly educated group of volunteers: all of them have at least a bachelor's degree. In Miami alone, this council has trained over 500 volunteer consultants since 1985. These volunteers work on custom-designed projects with cultural organizations that can include anything from market research to financial management.

Using a simplistic opportunity cost approach to measure the impact volunteer workers have in the economy brings unrevealing results. As suggested by Colonna (1995), volunteer workers should be divided according to the type of job they perform to calculate a more accurate average of the wage they should be receiving. This calculation should include any benefit

and bonus a paid worker performing this job would earn. This volunteer input represents savings these cultural organizations are making. On the other hand, it is time taken away from the actual jobs these volunteers do, which is to say that they potentially work less, which in turn translates into the government receiving less revenue in form of income taxes. Weighting these benefits and costs and obtaining some measure of net welfare change is necessary in order to assess the real impact of volunteers on the economy.

Gapinski (1980) and Hua Li (1991) made attempts at calculating the production functions for nonprofit cultural organizations. They not only encountered measurement and specification problems, but they also ignored serious issues of simultaneity.

We could go around all these difficulties by calculating the average wage rate for administrative and artists in the arts sector and compare this figure to similar average figures for different industries in the rest of the economy (Netzer, 1978). If the wage rate is higher for the arts sector, we could take this extra income as a measure of an extra gain producers receive out of government subsidy. This analysis would assume that any extra or surplus money artists make is artificially created by the government subsidizing this sector.

Corporatist Approach

From our discussion of the input-output model and the cost-benefit approach, we can establish the characteristics more efficient evaluation techniques should have. When evaluating cultural strategies, the researcher should consider that the members of each coalition interact differently from to city to city, utilize different inputs and produce different outputs. The evaluation must also take into account the strategies used by nonprofit arts organizations to obtain funding from private donors and arts agencies, and how they compete against one another for the same resources. The role of

each of the sectors should be specified while explaining how their actions alter the economy. Finally, for estimation purposes, the researcher must be aware of the limited data availability still prevalent on the nonprofit arts sector and find creative alternatives or proxies. All this implies that a more effective cultural strategy evaluation should:

- formulate a conceptual model that describes all the agents involved in the development process and how they interact with one another. The goals of these members should be modeled in terms of how they are obtained and at what cost.

- describe and analyze the qualitative aspects of the process. In the case of cultural activities and their effect on development, fields other than economics should be integrated into the analysis. When dealing with cultural policy evaluations in Europe, Sudbury and Forrester (1996) not only estimated the output of the programs and explained their sources of funds, but also made the distinction between the cultural reasons for development (description of the cultural activities in the area that potentially can trigger development and why they were chosen), and the regeneration reasons for development (economic reasons for the program). The researcher should also be able to explain how the close interaction among the government, nonprofit organizations and the private sector, and their implicit or explicit division of labor generate more efficient results than would have been obtained otherwise.

- define some particular output or goal. As Boivard (1992) explains, most studies focus on net employment creation, reduction of unemployment levels, and employment effects on target social groups (e.g., minorities, the young

unemployed, and inner-city residents). Few studies have looked at the more general "economic growth" effects of these policies like output growth or income generation.

- estimate the additionality of the public-sector contribution. Cultural strategy evaluations should establish whether public intervention influences the likelihood of success a private or public project already taking place. Authors like Wasimer (1994), Boviard (1992), Foley (1992) and Papke (1991) have used simple regression analysis techniques to isolate the additive effects of local incentives. Papke (1991), for example, analyzes the effects that the Indiana enterprise zones program has had on local employment and investment with a panel of local taxing jurisdictions. In this case, various objectives are considered and used as dependent variables (level of inventories, machinery and equipment, or unemployment claims). Even though these models assume that we all know how the government and the other sectors behave, they are beneficial when trying to determine if in fact government expenditure has an effect on obtaining a particular goal.

Chapter 4 provides a case study on using this "corporatist approach".

Notes

[1] Input-output models are called open when the household sector is part of the exogenous final demand.

[2] Specific instances where arts managers confessed to this alteration of the data cannot be reported. Many phone conversations with arts managers for this survey and other studies has provided enough stylized facts that could lead to other research papers where the incentives for administrators to conceal information to arts agencies is analyzed.

[3] Where in the second phase of the survey, a very careful or intensive gathering of data is made on a small sample of the original phase.

[4] Villamil's study lacks actual data on the amount of tourism international students at Florida International University attract to Dade County. It assumes that these students receive two visitors per year and spend $800.00 per visit (based on the Greater Miami Chamber of Commerce). The Port Authority, on the other end, used databases like the Air Passenger's Survey, Travel Intelligence System and the In-Flight Survey of International Air Travelers to assess the impact of tourism and arts in the local economy. They estimate that 12% of tourism expenditure goes to entertainment and cultural events. Finally, Van Tuyl uses data for Florida in 1994 from the White House Conference on Travel and Tourism and estimates that 17% of tourism in the Florida area are "culture tourists".

[5] Exceptions to this rule are students. Pommerehne and Frey (1990) point out that when students are given free tickets to any cultural event, they tend to attend even if this taste has not been acquired yet. Students, then, behave as "want-to-be's" that follow the norms of the society they expect to belong to after they complete their studies.

[6] See Appendix B.

[7] This restriction suggests that all income should be spent.

[8] Pignataro (1994), however, objects to this subjective use of the quality variable.

[9] Two % of hours worked by all artists, administrators and volunteers.

4 Art Deco, Arts Centers and Redevelopment: The Case of Miami Beach

Introduction

Visualize a run down American city in the late seventies where all the retail stores are boarded up and the street corners serve as full functioning bathrooms to the homeless. Now imagine the impossible. Visionary artists and preservationists migrate to the city to rebuild empty warehouses and buildings and make them into performing arts theaters, concert halls, nightclubs and restaurants. In less than twenty years, a strong public space and image is built inviting tourists and real estate agents to visit and invest. Once a community of retirees and recent Latin immigrants, the city is taken over by the young and genetically beautiful, the glamorous world of Hollywood and the Hispanic beat of the major Latin television and radio stations. How did this city, Miami Beach, Florida, initiated this process of economic redevelopment? It will be argued that nonprofit arts organizations initiated this development path guided by a strong commitment to preservation and artistic insight, and enticed by very low rents. The cultural resurgence in the area attracted real estate investors and tourists who in turn have started establishing and pushing different sectors of the economy. This type of arts-led revitalization plans in other American and European cities is, however, the best example of failed attempts at pursuing use values and exchange values simultaneously: gentrification being its most common symptom. Furthermore, market distortions are created by the local

governments crowding out their own attempts at supporting and encouraging economic redevelopment.

The arts-led regeneration program in Miami Beach is an ongoing process that allows the researcher to both analyze and be an active part of the phenomenon. This study proposes to depart from the standard regional and cultural economic tools ("economic impact studies") and explore the economic, artistic, social and political aspects of Miami Beach's revitalization plan. The roles, function and comparative advantage of the different types of organizations involved in this type of development processes will be explored.

In specific, five areas will be dealt with:

1) cultural reasons for development;
2) regeneration reasons for development;
3) sources of funds and political interactions;
4) estimation and evaluation of output produced by government expenditure in the arts; and
5) forecast of events.

Definitions

In this study, the term "the arts" will encompass activities that are preeminently urban in nature: printing and publishing, parks and recreation, broadcasting, live and recorded music, film, video, photography, advertising, performing arts, visual arts, design and fashion, museums, heritage houses and heritage restoration and preservation (see Harvey, 1993). These activities can be temporary (e.g., festivals) or permanent (e.g., concert halls), and can produce arts for consumption or make the production of arts possible, such as auditoriums and educational institutions.[1] Local economic development, on the other hand, will be used in a more limiting way: it will refer to the shift in the level of business in the

community. We link the two by assuming that the arts sector helps reshape and rebuild the physical environment in urban centers and encourage consumption patterns that are less wasteful of exhaustible resources than other types of consumption. In other words, the true significance of the arts in urban development lies on the improvement and attractiveness of the city's image. Under these assumptions, culture helps attract and retain new businesses, increase the community pride and spirit, and improve the chances for success of larger local development projects. A cultural strategy then becomes the effort of an intended or unintended coalition of public and private agents to generate arts activities that will unite all sectors of the community to promote local economic development.

On Historic Buildings, Arts Centers and Pavarotti

Picture it: Miami Beach, 1915. Carl Fisher, an Indianapolis automobile baron turned real-estate developer, is trying to prove that his dream of making Miami Beach into a prosperous city can be a reality. But what will be true 70 years later was stopping Fisher then: Miami Beach seems unreal to visitors; no one believes the city will last. Eventually, as Armbruster (1995) describes, Fisher was driven to offer free lots to those who would build substantial structures on them. Even then, he only got a handful of takers. After WWI, Fisher changed his tactics and offered potential buyers to raise land prices ten percent every year, ensuring investors that property would become more valuable. With the offer, Fisher not only established the first polo field off Lincoln Road but also paid celebrities to play in it. This time Fisher was more successful and the Beach saw its first economic boom. Ironically enough, the city did not develop completely until the Great Depression. As Reese (1989) describes, the Miami Beach of the 1930s benefited tremendously from the influx of two

groups: wealthy tourists that came to Miami to escape the cruelties of the Depression and the northern weather, and European Jews escaping from Nazi persecution. Reese reports that between 1930 and 1940, 200 hotels and 1,180 houses were built. Much of this construction was going on in the undeveloped land south of Lincoln Road, South Beach. And if they had Polo in the Twenties, the Thirties brought the consolidation of the Lincoln Road area as the place where shopping was reserved for the wealthy, the East coast café society mingled with gangsters and sports legends, and the community enjoyed watching celebrities and experiencing glamour.

The Thirties brought as well the consolidation of Tropical Art Deco as the architectonic signature style of the city. Art Deco came to Miami in 1929 with the Sears Roebuck & Company department store. As the style became more popular, the motifs became uniquely Miami's with touches of Streamline Modern and tropical themes. Meant to express power, authority, progress and modernity, Miami Beach saw in Art Deco the solution to their weak zoning laws. This lack of regulations kept the buildings very close to the street and each other. To assert personality and attract customers, architects added to the buildings high columns on the ceilings, rounded corners, and flamingo and nautical designs. By the end of the 1950s, the style and the city had been immortalized in TV shows and movies.

Like any city dependent on real estate, Miami Beach went from boom to bust every so often and experienced like no other city the high-rolling years of WWII, the advent of television, and the sophistication of the Fountainbleau Hotel and the Eden Roc. By the late 1950s, the glamour and luxury was beginning to fade. With business slipping, the city closed the streets at both ends of the Lincoln Road and made it into a pedestrian mall in 1960. Ten years later, all the luxury stores had been replaced by girdle stores and tourist shops hawking alligator ashtrays and flamingo-shaped salt and pepper shakers.

Historic Preservation in Miami Beach

The 1970s. Miami Beach is dead. If you ask city officials, arts administrator and hotel owners, "What killed the Beach?", you'll be sure to get a wide range of answers: too much success killed the Beach; the Caribbean killed the Beach; the "marielitos" killed the Beach; the Hispanics killed the Beach; the old Jewish killed the Beach; I-95 killed the Beach;[2] the city government killed the Beach; recession killed the Beach; inflation killed the Beach. And as Armbruster (1995) got to hear herself: "women's lib killed the Beach".

Whatever caused it, its symptoms were clear: the number of tourists sharply declining, the South Beach area (or Old Miami Beach) becoming the poorest neighborhood per capita in the state, and maternity wards and elementary schools being scaled back or closed altogether.

The city invested large amounts of money in hosting political conventions, sponsoring an enormous beach-replenishment project and, most importantly, demolishing old Art Deco buildings so the city could start all over again. While this is all very well documented (Armbruster, 1995; Reese, 1989; Allman, 1988), what happened next takes a truly legendary character.

Enter Barbara Baer Capitman. Some say that she was simply looking for something to do after her husband's death; others claim that she and her friend Leonard Horowitz, an interior designer, were looking for a "cause"; while others claim that she was honestly concerned, horrified, at the idea of losing 1920s and 1930s buildings in the name of development. Whatever it was, legend tells us that her absolute insane passion for these buildings made her chain herself to historic buildings that were scheduled to be demolished.

Armbruster (1995) portrays Capitman and her movement (which later became the Miami Design Preservation League, MDPL) as a very uninformed and disorganized nonprofit organization. But their records and achievements show otherwise. The "statement of significance" in the historic nomination submitted to the State Historic Preservation Office in 1978 shows their precise definitions and objectives:

> Old Miami Beach is significant because this 1.0 square mile area contains the largest concentration of early twentieth century resort architecture in the Untied States. There are approximately 1200 buildings remaining, which are presently used for residences, commercial enterprises, and as hotels. Their construction dates between 1923 to 1945. Resulting from a combination of historical and economic forces, the area developed rapidly, netting an extraordinary architectural consistency. Surveyors have identified over four hundred noteworthy buildings in this district. In the past two and a half years, through the efforts of an advocacy group the area has come to be recognized as the Deco District, and Art Deco has become a familiar and popular term applied to many buildings in the district.

With the help of architects, preservation consultants, and members of the community, the MDPL completed a comprehensive historic district plan that linked their preservation goals and economic development. The MDPL was to (Raley, 1994):

1) establish a financial plan for the funding of an historic restoration district;
2) develop a plan based upon the unique nature of the Art Deco architecture designed to attract new businesses into the area without displacing the local inhabitants;

3) recommend financial programs and policies to the City which would enhance the success of the Art Deco Restoration District;

4) assess the impact of a historic district on the economy of the City of Miami Beach. This would include but would not be limited to the impact upon the tax base of expected alterations in the area and the impact on the areas' real estate market; and

5) provide policy recommendations for continuing the restoration of the Art Deco district which is supported by a volatile economic base.

What the MDPL never expected was that the bureaucrats at the City of Miami Beach would oppose their plan. The city sent three representatives to fight against the proposal at a state preservation board hearing. The city argued that Preservation was bad for development. It would stop it. Their plan included replacing the old buildings with luxury hotel, condos, restaurants and shops. Behind this plan lay the unspoken belief that there were too many old people in the district, their unfashionable presence clashing with Miami's plans to attract a younger market. The proposed resort area meant that the retired Jewish and the Latin immigrants would have to move out as the plan included destroying the buildings in which they lived. To fight this government plan, the MDPL had to persuade Dade County to sue the city of Miami Beach so it would lift the moratorium on renovation and remodeling it had imposed on all buildings since the late 1970s. The opposition was so fierce that Horowitz and a group of volunteers, with no funding or equipment, would go directly to building owners and ask them for their support: if the owner provided the painting, they would "patch up" the place...for free.

The MDPL reached its goal on May 1979. It took Barbara Baer Capitman and her "followers" more than three years packed

with meetings, lobbying efforts and tough financial times, to make of Old Miami Beach a "Historic District". This designation assured all the state, federal, and private grants that come with the designation.[3] And, yes, the city of Miami Beach was the first to congratulate the MDPL for its accomplishment. With the congratulations came the Ocean Drive Street-widening project, a joint effort by the city and business owners. The fifteen-month project allowed enough space for outdoor cafes and served as a catalyst for development in the area by attracting local and tourists alike. Soon after that, the Facade project was first designed and implemented by the city. The program, still in place, consists of a state and federal grant program that the city manages and awards to any real-estate developer or property owner interested in renovating the facade of an Art Deco building. The grant program covers a substantial fifty percent of the cost of such renovations and comes as a means of alleviating the extra cost that historic preservation imposes on remodeling any Art Deco building in terms of extensive restrictions and limitations.[4] The City government even linked preservation and planning and development by including the following goals in their 1979-1980 budget:

1) to support the economic revitalization of the city by encouraging a variety of housing and commercial shopping opportunities within the District; and
2) to preserve the architectural identity of the District and significant structures throughout the city, and encourage community recognition in appreciation of its social and cultural heritage.

But even when the city agreed to participate in the creation of a historic district plan, and funds were appropriated by the city Commission to further the preservation effort, city planning did not include historic preservation within their Comprehensive Plan. In

fact, the city has created and reclassified their Preservation department at least ten times in the last 15 years, repeatedly changing its goals, reach, funds and even closing it altogether. The conflicts between the city and preservationist continued as the City responded to commercial developers who insisted that the Art Deco buildings were not attractive and were not historic. Some developers felt excluded from the preservation process since they were never invited to participate in any funding proposals. These developers, like many city officials, felt that the MDPL was nothing else but a front for Barbara Capitman to make money.

Private agenda or not, publicity for the Art Deco District started to snowball. As Armbruster (1995) describes, articles about the area appeared in all hip young American and European magazines. Fashion photographers discovered that the lights on the beach were as good for photographing bathing suits and spring-catalog clothing as they were in the Caribbean, and Florida had Fed Ex! In fact Miami Beach became "overexposed" when in the early eighties events like the Christo wrappings, Christo living in one of the Art Deco hotels, and the TV show *Miami Vice* gave worldwide coverage to every single activity on the Beach. Tourists and young renters trickled in and the real estate developers were not far behind.

On the north side of the Art Deco area, the Lincoln Road Mall had hit bottom by late 1970. There were many failed attempts at redeveloping the area, but at the end, all that was left were a few flop cafes and bars. The area was mostly boarded up, and served as full functioning bathrooms to the homeless.

Enter Ellie Schneiderman. By 1984 her South Florida Arts Center (SFAC) had outgrown its first house in Coconut Grove, Florida. This center, that primarily provides studio and housing for artists who agree to show their work periodically, was fundamental in the redevelopment efforts of Coconut Grove. Victim of their own success, Schneiderman had to move the SFAC to a more affordable area and saw in the Lincoln Road Mall the infrastructure

needed to build an arts center: plenty of empty retail stores at very low rent and inexpensive apartments and studios very close to the beach. Scheneiderman's organization and dream counted with the professional support of lawyers, real-estate developers, and the monetary help of grants from Dade County and the city of Miami Beach. While she was selecting the artists her nonprofit organization would subsidize, her lawyers and developers were advising her to buy the twenty store fronts she was renting, just in case the SFAC became too successful again. But success did not come easily. In the beginning, all the SFAC could only afford to attract "average" artists who produced "mediocre" works that no one wanted to see or buy. The artists themselves had to deal not only with derelict studio spaces, but also with the toughest audience in town: retired ladies that attended the SFAC opening nights to eat the complementary cheese and take some home in their big bags. Little by little, as the Lincoln Road Mall area became more popular, more famous artists started to notice the SFAC and became interested in being part of the group. Their displays on store-front windows eased the ghost-town image that was pulling the area down. As more artists came to the SFAC, more patrons and donors were invited and interested to attend opening nights.

In 1986, the Lincoln Road area receives another push as the Miami City Ballet (MCB) opens its doors. Through a good rent deal, the owners of the building persuaded the MCB not to close the store-front windows of the building and let the pedestrians watch their rehearsals and classes. The novel idea became an instant success and attracted more of the right pedestrians and shoppers to the area.

In 1987, the Colony Theater, previously owned and managed by the city, enters a new stage when the Concert Association starts running this performing theater. The city turned the building to the Concert Association "free of debts" (it is estimated that the Colony Theater owed $300,000 that the city

paid) but with a structure that was in shambles. After some renovations, the Colony Theater opened its doors to house performances for smaller nonprofit arts organizations. That same year, the Alliance Theater, also attracted by the low rents, opens its doors to the public. The idea of opening a theater to show avant-garde, "weird" movies in that deserted, blighted area was considered ridiculous by many. And maybe it was. Faced with a tough financial situation a few years after it first opened, the theater survived the tough times by targeting to the new residents of the beach: gays and lesbians. In the mid-eighties, magazines like *Out* and the *Advocate* started to advertise the Miami Beach area not only as a gay friendly city, but also as one where the "medical care of HIV" was among the best. The gay male market (the one affected the most by the HIV crisis) is usually described by marketing companies like Overlooked Opinions (O.O.) as a highly educated, high income, trend-setting market. O.O. claims that gays and lesbians have a higher "disposable" income since they usually have no children. This higher spending income is used in renovating houses, going out to restaurants and bars, and attending the type of events nonprofit arts organizations produce. Organizations like the Area Stage, the Wolfsonian (which houses exhibitions on design and propaganda of the Art Deco era), Edge Theater, Ballet Flamenco La Rosa, the Performing Arts Network, the Miami Light Project, and the Bass Museum found in the gay market the best consumers and donors.

For three years, the New World Symphony[5] (NWS) performed in auditoriums like the Colony Theater and the Gusman Center (in Downtown Miami). In early 1990, with private support and a generous endowment fund, they renovated the Lincoln Theater, one of the gemstones of the Art Deco district. Like the Alliance Theater that provides educational and technical services to the community, the NWS does much more than concerts. The NWS is composed by a hundred recent college and Master graduates that find in the organization the best way to promote

their careers. They not only receive a weekly $350 salary, but also a studio or an apartment (the renovated "gemstone" Plymouth hotel) and the opportunity to perform in-house and abroad with the best conductors in the world. In exchange, the young musicians provide free and paid concerts to the community, coaching and mentoring to high school students, seminars and master teaching.

By 1992, the nonprofit arts movement, with all its avant-garde connotations, went officially mainstream when Pavarotti performed on Ocean Drive and Tenth street with an attendance of more than two hundred thousand people. The Concert Association coordinated this effort for eight and a half months with the assistance of a modest grant from the government-run Visitors and Convention Authority (VCA) and in kind services provided by the government. This concert put the Beach not only in every single magazine of the world but also on their covers. With the exposure, Miami Beach became the Mecca for the young and the professionally beautiful. A dozen modeling agencies where none existed before now cater to the demands of the global fashion, film and music industry. In fact, the Dade County area is today the third largest center for movie, TV and print production in the country (for details see Table 4.1). With this distinction comes the famous visitors that bring back to the Beach the glamour of the twenties and thirties. Regulars (and even residents) to the Beach include Sylvester Stallone, Madonna, Cher, Mickey Rourke, Robert de Niro and Miami's own Gloria Estefan. This resurgence is reflected in the amount of sales by the Miami Beach Convention Center that has almost doubled in the last six years, and in the collection of resort tax by the City of Miami Beach (see Table 4.2).

The very nature of the "Hollywood" industry only adds to the risky or speculative character of the Miami Beach development process. The fortunes of local bars and restaurants that rise and fall at astonishing rates illustrate the transitory nature of this process. But as indicated in Table 4.3, the building construction

Table 4.1 Film and Print Activity in Miami Beach

Year	# of film and print permits issued	Production Budget (in million $)
1990	1281	57
1991	1604	44
1992	1901	49
1993	1871	59
1994	1827	52
1995	1939	59
1996	1900	60
1997	1936	58

Source: Miami Beach Statistical Abstract 1995 and Film and Print Department of the City of Miami Beach.

industry presents us with a different perspective. Miami Beach's real estate business has flourished dramatically in the last 15 years. From remodeling buildings, to the construction of high rises, hotels and retail space, the Beach has changed the way investors evaluate the risk involved in building at the Beach. Although it has not reached the security level of building a mall in the suburbs, investors keep track of the openings of popular mainstream stores and restaurants in the South Beach Area and see it as a sure indication of the stabilization in the real estate market. In fact, according to the 1996 Miami Beach Statistical

Table 4.2 Resort Tax Activity: City of Miami Beach Resort Tax Collections (in real terms 1982=100)

Year	Resort Tax Collection (in million $)
1977	5.13
1978	4.72
1979	4.41
1980	4.19
1981	4.39
1982	3.81
1983	3.42
1984	3.31
1985	3.27
1986	3.45
1987	3.87
1988	4.01
1989	4.27
1990	4.47
1991	4.55
1992	5.03
1993	5.35
1994	5.14
1995	5.78

Source: City of Miami Beach Annual Budget.

Abstract, employment in the construction industry increased by 62% in the last ten years while employment in the Finance, Insurance and Real Estate (FIRE) industries increased by 30.5%, accounting for 42.5% of employment in the city.

The residential real estate market had been showing considerable increase even before Hurricane Andrew hit the city in

Table 4.3 Building Permit Activity in Miami Beach

Year	Residential Permits	Value (in millions $)	Commercial Permits	Value (in millions $)
1983	1358	9.0	531	11.6
1984	1460	17.2	577	42.5
1985	1178	17.2	475	22.6
1986	1198	33.8	481	31.4
1987	1793	24.5	365	62.8
1988	1804	20.8	572	38.1
1989	1825	98.7	659	37.2
1990	2039	82.3	461	13.6
1991	1916	58.3	649	14.3
1992	1972	32.9	765	16.9
1993	3146	184.5	888	46.7
1994	2596	121.3	747	41.4
1995	2132	172.7	681	31.6

Source: City of Miami Beach Annual Budgets

1992. The commercial market, on the other end, while showing modest increases in the amount of building permits, shows a strong increase in the value of building construction.

Development Results Ironically enough, the original revitalization strategy the City of Miami Beach had planned occurred naturally. As the facade of buildings, retail shops and hotel was renovated and improved, the value of the capital of the city increased. As the original members of the city were ignored in the development process and did not receive the training (that translates into better jobs) they could not take advantage of the increase in value of capital. Gentrification occurred. By early 1996, a Miami Herald

article by Rick Jervins announced the demise of the arty Lincoln Road area. The arty feeling was gone and privately-owned high-priced firms like Lace Gallery, Sony Music, and MTV Latino were taking over. One of the groups that had to leave the Lincoln Road Area due to the high rents is the Ballet Flamenco La Rosa. This dance group, much like the Miami City Ballet, attracted visitors to the area by rehearsing and performing on the store front windows of their studios on the Lincoln Road Mall. When they were forced out of the Road, their organization and the arts community on the Beach grew stronger: Ballet Flamenco La Rosa formed the Performing Arts Network (PAN). PAN found its house at a studio space next to the Concert Association and since then has been providing rehearsing space to performing artists, and teaching arts classes to the community.

But while artists are already used to this leap frog effect and have already found a new arty place in a different city in Dade County, the story is a little different for another group of people. Barbara Capitman's dream did affect the very group she once wanted to protect: the retired. By 1995 the Miami Herald started to chronicle the migration of the elderly population of the Beach. As rents were skyrocketing, and businesses wanted to expand, there was no more room for the retired. Sales and Marketing Magazine's Survey of Buying Power shows how in 1976 almost 72% of the population in the city of Miami Beach were over the age of 50. Since 1991, that number has gone down to 44% and decreasing. The major reason for the decline of the elderly on Miami Beach is death and a lack if immigration, Sheskin (1994) claims. Most of the elderly population that accounted for 72% of the city in 1976 would be dead by now. While the elderly are still moving to South Florida, they are not coming to the Beaches in any significant proportion. Rather they are moving to assisted-living centers in Broward and Palm Beach counties.

Local Government and Its Contribution to Development

The city government's contribution to development process can be divided into six areas:

1) *Area Improvement.* Public works projects like the Lincoln Road Street improvement, North Beach Street improvement, Washington Avenue landscaping, Calais Drive street improvement, and code enforcement.

2) *Historic Preservation (Commercial).* The Facade Project, and the Museum Revitalization Projects.

3) *Historic Preservation (Residential).* The Rehabilitation Project, Special Needs housing, and Planning of Historic Preservation (for which the last allocated funds were in their 1987-88 budget).

4) *Arts Organization Support.* The city allocates funds to sponsor cultural affairs, recreation, and arts, and to cover the operating expenses of the Bass Museum The South Florida Arts Center has received from the city, for instance, at least $2.6 million dollars in the last ten years as a result of a very active development program. They argue, among other things, that the SFAC was (and still is) the catalyst for the development of the Lincoln Road Area. Without the American and foreign artists they subsidize and the works they display on their storefronts, the Lincoln Road Area would lose its feeling and character. In fact, it was through the SFAC lobbying efforts that the area that covers eighth to tenth street on Lincoln Road was declared an "Arts District". This denomination that is no more of a show of intent at least supports the zoning law that prohibits any storefront space to be rented for offices.

5) *General Funding for Education, Parks, Recreation, and Libraries.*
6) *Visitors and Conventions Authority.* Covers funds for any special event that potentially can attract visitors and conventions (see Table 4.4).

Funds for all these programs come from sales taxes, property taxes and federal and state grants. The City Budget Department does not keep an exact breakdown of the origin of the sources for cultural funding.

Table 4.4 Miami Beach Visitor and Convention Authority Cultural and Special Events Funding

Fiscal Year	Funds ($)
1989-90	607,497
1990-91	532,540
1991-92	632,000
1992-93	596,200
1993-94	596,200
1994-95	636,825
1995-96	623,825
1996-97	524,500

Source: City of Miami Beach Annual Budgets

Government, Nonprofit and the Private Sector: Their Interaction

After the victory of the MPDL, the government took a less proactive attitude towards development and limited itself to provide a steady stream of resources to build and recreate the public space Miami Beach so much needed. It also set the

priorities of the city by requiring any group asking for grants or funding to prove that they were in fact trying to promote development. For instance, when nonprofit arts organizations request funds from the Visitors and Convention Authority, they have to prove that the event they are organizing will bring visitors to the area or make the city more attractive for conventions and larger special events. This very set of priorities ensures that the arts organizations produce at the level of quality that attracts the general audience. In many interviews conducted for this study, however, arts managers, artists and entrepreneurs expressed their disappointment with the support the city government has given to them. They believe that the government should provide direct funding to organizations that perform on a permanent basis on the Beach instead of just managing or giving grants for specific festivals. They seem to be unaware of the impact street improvement projects, lighting, and others have on development. On the other hand, the complaints of arts managers may be justified. The city government never made the arts and culture funding a priority until 1997.

The very erratic history of their Historic Preservation department shows the city's lack of commitment to the Heritage movement. It was not until 1989 that the city opened the Historic Preservation and Urban Design department only to close it two years later. In 1996, the department re-opened as the Development Design and Preservation. This department, unlike its predecessor, lists in its annual-budget request, goals like promoting economic development through Preservation and provides some strategies to accomplish it.

The image of a non-cooperative government, prompted nonprofit and private businesses on the South Beach area to form Street Associations. Ocean Drive restaurant and hotel owners, for example, formed the Ocean Drive Association, the same way the Lincoln Road Mall shop owners and artists formed the Lincoln Road Partnership. These associations obtained permission from

the government to "tax" themselves to fund their own cleaning, police protection and minor street repairs. They also were very active in city politics. When the city proposed opening the east-west Lincoln Road street to cars, the Lincoln Road Partnership managed to keep the pedestrian-friendly structure and arty feeling the "Mall" has. Through political maneuvering and a clear artistic vision, the Lincoln Road Partnership agreed to "look into the matter". They delayed any final decision by bringing speakers, and commissioning studies to explore the impact of such changes. By the time they reached a conclusion, the one they had always had, the public itself had been informed of the city plans and opposed any changes to the street.

By early 1997, the situation changed drastically. The new city manager withdrew its support to all street organizations and decided that the city would take care itself of all police protection and cleaning. Projects like a convention hotel and a 14-screen movie theater at the west end of the Lincoln Road Mall that had been widely opposed by artists and some real-estate developers are now been sponsored by the city. Tax credits for renovation and historical preservation have been reduced in the last two years and the city has approved the construction of many high-rises that required the demolition of Art-Deco historic buildings.

Counteracting this new philosophy, arts organizations and some city officials united to form an Office of Arts, Culture and Entertainment. This office is intended to promote the film and music industry in the city and facilitate their relocation, implement the programs of a newly formed Cultural Arts Council (including its grant programs, facilities, development and marketing), and attract conferences. For 1998-99, the budget of this department was $340,704.

As part of these conflicted cultural coalition, the nonprofit arts organizations have made possible the personalization and distribution of services. The crew at the Alliance Film-Video cooperative, for example, has enough contact with videographers

and performing artists as to realize the need for a low-cost video producing company. The Edge Theater and the Alliance Theater are one more member of the community and understand the need to program gay-oriented films and plays. Moreover, their small size lets them operate at more efficient rates than any other government bureaucracy, and allows them to quickly re-structure their objectives and functions as the needs of the market change.

Closing this circle, we find the business sector instilling that competitiveness instinct that nonprofit arts organizations tend to lack. This is reflected in commercial property owners persuading their renters to allow the public to watch their rehearsals, or for-profit entertainment companies adding value to their season tickets by providing discounts in exclusive restaurants of the area.

Evaluating Local Government Support to the Arts and Its Effects on Development

The effects of local incentives to cultural activities on the redevelopment of Miami Beach will be discerned in this section. First, a conceptual model needs to be formulated to provide guidance for carrying out the empirical work. This model provides the basis for selecting the explanatory variables to be included in the analysis. It also helps avoid omitting important variables (and the biased coefficients associated with it).

The Conceptual Model It has been assumed all along that nonprofit arts organizations have had an impact on the level of development of the City of Miami Beach. On the previous section, we concentrated on describing the events occurring between 1977 and 1995 in Miami Beach, Florida as a way of offering some stylized facts that could support our assumptions. This conceptual model will formalize our description of the goals of the agents involved in the process and how they obtain them.

Using Zukin's (1995) framework, the nonprofit arts organizations will be the suppliers of the ambiance and image of the city (i.e., public space); the same public space that will be demanded by the business sector which in turn will promote local development. In the case of Miami Beach, tourism will constitute the industry demanding the public space artists create. Local economic development has already been defined as the level of business activity in a community. Although some local policy makers and regional planners like to evaluate business activity based on employment, (see Bovaird, 1992) it may be more appropriately measured by a broader criterion like sales or receipts. In the specific case of Miami Beach, it will be posited that the level of resort tax collection (TOURISM) is a reflection of the level of development of the city. In turn, the amount of resort tax that the city of Miami Beach collects (TOURISM) every year will be determined by the interaction of the supply and demand of public space. Formally,

Tourism = F (Supply-determining factors, Demand-determining factors) (4.1)

Given all these assumptions, we can start modeling the behavior of these two sectors. Notice how these equations serve mainly as a tool to formalize all the assumptions made throughout this chapter about the behavior of these entities.

The Image Suppliers It is safe to assume that nonprofit arts organizations have multiple goals. To model their behavior, the major tools to accomplish these goals should be analyzed.[6] We will assume that these organizations choose their performances and business location, the number of events (concert, restoration projects, etc.), quality of performance, and prices, letting the market or the interplay of supply and demand choose the equilibrium quantity or attendance value.

Given these assumptions:

1) What considerations do artists make when deciding where to locate? Their business location (LOCATION) will be a positive function of the availability of arts facilities (studios, warehouses, retail space) or the need of redeveloping a building $SPACE_{AVAIL}$. It will also depend positively on existing arts facilities ($SPACE_{EXIS}$). This claim assumes that there is some type of positive externality from proximity. Location will also depend positively on the economic incentives provided by the city to artists (denoted as INCENTIVES). We will assume that nonprofit arts organizations suffer a response lag to these incentives. That is, they do not respond to this year's local incentives until the next period. For instance, nonprofit arts organizations plan their location, events, and how much money they will spend on them before the season starts. The very organization of these events gets in motion before the season begins and the schedules of events are usually designed and printed months in advance. They consider the INCENTIVES they are receiving this year in terms of how they will affect their plans for next season. To simplify our model, we will assume that any incentive policy that is implemented by the local government minimizes the use of resources necessary to ensure its goals.[7]

Finally, the business location will be negatively related to the rent rate of the space ($SPACE_{RENT}$). Formally this function can be written as,

$$Location = f(Space_{AVAIL}, Space_{EXIS}, Incentives_{-1}, Space_{RENT}). \quad (4.2)$$

2) Once the business location has been decided, these arts organizations have to choose the number of concerts they will schedule for each year. For each organization, the number of cultural events (EVENTS) will positively linked to the lagged preferences of their audience in terms of demographics, patterns of

consumption attendance to cultural events (PREFERENCE-1)[8] and the amount of individual donations (denoted $DONATIONS_{-1}$), (i.e., an increased amount of donations would provide more resources to program more concerts). As in the case of local incentives, arts organizations can only respond to their audience's preferences a year after they learn about them. Actual donations to nonprofit organizations in Miami Beach could prove impossible to collect as there are more than 70 of these organizations and the nature of most of them is not to keep reliable data for such a long time. On the other end, nonprofit institutions frequently spend large amounts of resources on fund raising activities. Whether these expenditures should be considered as part of the price of giving and whether they actually affect donations are issues that have been a source of debate in the literature (Weisbrod, 1988; Steinberg, 1986) and no clear agreement has been reached. According to Luksetich and Lange (1995), a safer alternative is to consider individual donations to nonprofit arts organizations as coming exclusively from the local residents and to assume that they vary positively with respect to the income and age bracket of the local community. In that case, DONATIONS is related to the vector of local characteristics of the community to be studied.

The number of events will be inversely related to the cost of putting together a performance or restoring a building (COST). When determining the exogenous and endogenous variables of these models, we only take the factor price of inputs as exogenous. Formally,

$$\text{Events} = f\,(\text{Preference}_{-1}, \text{Demographics}_{-1}, \text{Cost}).\qquad(4.3)$$

3) Arts organizations are now ready to choose the level of performance quality they will offer to the audience (denoted QUALITY). This variable could be measured in terms of cost of the production, the number of performers, critic reviews and so on.[9] QUALITY will be positively linked to subscription prices

(PRICE$_{SUB}$), number of events (EVENTS) (as it is assumed that quality, as perceived by consumers, increases with the number of performances), cost of concert (COST),[10] and individual donations (DEMOGRAPHICS$_{-1}$).[11] The level of local incentives from previous years (INCENTIVES$_{-1}$) will positively affect quality in two manners: by increasing the amount of production money or resources and by establishing well defined requirements as to who is funded and by how much. Formally,

Quality = f (Price$_{SUB}$, Events, Cost, Demographics$_{-1}$,
Incentives$_{-1}$). (4.4)

4) Now these organizations are ready to choose the subscription price to all their events (PRICE$_{SUB}$). They will take into consideration the characteristics of their potential market (i.e., income, and other demographic indicators). This variable will be denoted here as DEMOGRAPHICS and will have the same lag effect described for preferences and local incentives. The price charged will be positively related to the cost of the concert (COST); and to advertising expenses (ADVERTISING). This price variable will be negatively related to individual donations, DEMOGRAPHICS$_{-1}$,[12] and to the previous year's local incentives (INCENTIVES-1). QUALITY and CONCERT will positively affect the price variable. Formally,

Price$_{SUB}$ = f (Demographics$_{-1}$, Cost, Advertising, Incentives$_{-1}$,
Quality, Concert). (4.5)

Demanding Public Space Now that the behavior of the supply side has been explained, the manner in which tourists make their decisions will be explained. Tourism is often viewed as a unique commodity because it spans several segments of many industries and at the same time lacks a compact definition. As the 1994 Port Authority of New York and New Jersey Report explains, it is the

only export industry where individuals must actually travel to the source of production in order to consume the product. For this model, however, tourism will be treated like any other commodity. The analysis will be limited to that segment of the market that is choosing among places to vacation with similar weather characteristics. A model of why people choose Cleveland, Ohio in February instead of Miami Beach, Florida is beyond the scope of this paper.[13] Given all these assumptions, let us explore all the decisions a typical tourist would make.

1) The potential tourists must first choose the location they will visit (LOCATION). This decision will be positively related to pleasant past experiences at a particular place ($EXPERIENCE_{-1}$), which assumes habit formation (Becker, 1996).[14] Visitors will compare their potential destination's image and ambiance (IMAGE) and choose the one that best suits their preferences.

The income of the potential tourists will also affect positively their location decision (INCOME). This decision will be a negative function of hotel rates (HOTEL), traveling costs, which will be simplified by assuming that the tourists can only reach Miami Beach via airplane (TRAVEL), tourist visa fees (VISA), crime rate (CRIME), and cost of living of the areas (COL). Finally, the exchange rate (XRATE) will play a significant role in attracting tourists from other countries. An appreciated dollar will detract international tourism will a depreciated dollar will attract it (see Nwana and Gladson, 1996). Formally this behavior could be described as,

Location = f($Experience_{-1}$, Image, Hotel, Travel, Visa, Crime, COL, Xrate). (4.6)

2) Once tourists have decided on and traveled to the location, they must decide the length of their stay (LENGTH). The

longer the tourists stay, the more the community benefits in terms of more sales taxes, tips, longer hotel stays and so on.[15]

This LENGTH will be positively affected by the income of the tourists (INCOME). It will be negatively affected by cost of living of the area (COL). The preferences of the tourists (PREFERENCES) will affect this decision as well. Formally,

$$\text{Length} = f\,(\text{Income, COL, Preferences}). \tag{4.7}$$

3) Finally, tourists also must decide how much money they will spend while visiting the area (PURCHASES). This decision will be positively affected by variables like INCOME; and negatively related to the cost of living of the area (COL) while positively related to the cost of living of their place of origin (ORIGIN). (This last variable would account for domestic travelers). The exchange rate (XRATE) and the PREFERENCES of the tourists will also affect these decisions. Formally,

$$\text{Purchases} = f\,(\text{Income, COL, Origin, Xrate, Preferences}). \tag{4.8}$$

Structural Equations

This behavioral model leads to the following structural equations:

$$\text{Demand} = f\,(\text{Income, COL, Preferences, Origin, Xrate, Experience}_{-1}, \text{Hotel, Travel, Visa, Crime, Image, } e_1). \tag{4.9}$$

$$\text{Supply} = f(\text{Space}_{\text{AVAIL}}, \text{Space}_{\text{RENT}}, \text{Incentives}_{-1}, \text{Price}_{\text{SUB}}, \text{Cost, Events, Demographics, Advertising, Quality, } e_2). \tag{4.10}$$

and the third equation as specified before,

Tourism = f (Supply-determining factors; Demand-determining factors, e_3). (4.1)

where DEMAND refers to the factors determining the demand for public space, SUPPLY refers to the factors determining the supply of the public space, TOURISM refers to the level of resort tax collection, and the e_is are unobservable random variables. These structural equations describe the behavior of an economic agent, like our tourist or artist. We could solve the above equation for TOURISM, DEMAND and SUPPLY and obtain reduced-form equations. In the reduced-form, each of the endogenous variables is determined by all the exogenous and predetermined variables. Since we are interested in studying the level of resort tax activity in Miami Beach, a reduced form equation will be estimated for TOURISM where on the right hand side we will have all the exogenous and predetermined variables of the model. Since these reduced-form equations constitute a classical regression model, the ordinary least squares applied to them yield a consistent (but not always efficient) estimator of the coefficients. The tendency in the literature is to hypothesize about this type of relation between local development and public space without using a conceptual model that could provide guidance for selecting the explanatory variables to be included in the model. Without such guidance, the researchers could hypothesize a relation and later run regressions based on it without knowing whether or not the right hand variables in their equations are endogenous or not. Such variables should not appear as explanatory variables unless specific techniques designed for estimating simultaneous equations are utilized.

Our functions have both endogenous and exogenous variables on the right hand side. For this model, the endogenous variables are $PRICE_{SUB}$, COST, EVENTS, ADVERTISING, QUALITY, DEMAND, SUPPLY AND TOURISM. The exogenous variables are: INCOME, COL, PREFERENCES,

ORIGIN, XRATE, EXPERIENCE$_{-1}$, HOTEL, TRAVEL, VISA, CRIME, IMAGE, SPACE$_{RENT}$, SPACE$_{AVAIL}$, DEMOGRAPHICS, and INCENTIVES$_{-1}$

The reduced form equation for TOURISM to be estimated is:

$$TOURISM = r\ (COL, Local_{-1}, Crime, Origin_{VISITOR}, Xrate,$$
$$Experience_{-1}, Travel_{MB}, Image_{MB}, Space_{MB}, and\ Incentives_{-1}).\quad (4.11)$$

where TRAVEL$_{MB}$ is a vector of costs associated with traveling, LOCAL is a vector of market characteristics (e.g., demographics), IMAGE$_{MB}$ is a vector of characteristics associated with major cultural activities and events that affect the image of Miami Beach, ORIGIN$_{VISITOR}$ is a vector of characteristics of the place of origin of the visitor, and SPACE$_{MB}$ is a vector of characteristics associated with rent space in Miami Beach. Since we are primarily interested in the role of the ambiance or image of the city on local development, our variables of interest would be INCENTIVES given by the government to the artists, the IMAGE and ambiance created by artists, and the LOCAL characteristics (as it has been assumed that artists start a gentrification process that improves the image of the city and that would be evident with a younger population and residents with higher income).

Empirical Considerations and Results

The empirical estimation of what determines tourism over time requires a city data base consisting of all the variables in the equation. The scarcity of such data makes regression of this type rather difficult. In particular, the lack of a comprehensive survey to indicate the satisfaction level of tourists to the Miami Beach area (EXPERIENCE$_{-1}$) prevents us from including that variable in the specification.[16]

A set of data was obtained through a diverse number of sources and corrected for inflation using CPI for all urban consumers in Miami Beach 1982-84=100. The data expand from 1977 (a year before the MDPL starts its efforts to declare Old Miami Beach a historic district) to 1995 (based on the available data).

Description of the Data

Tourism Variable The amount of resort tax collected by the city of Miami Beach was used as an indicator of the level of tourism (Table 4.2). The rate charged by the City of Miami Beach remained constant for the time of the study, with the exception of the 1994 and 1995 figures. In 1994 the rate was increased by one cent. The City of Miami Beach Statistical Abstract 1996 and the amended City Budgets provide figures for the resort tax collected for the previous rate and the new one separately.

Local Incentives to Cultural and Recreational Activities Information on funds allocated to cultural affairs, recreation, the performing arts, and development and historic preservation was gathered from the annual City Budgets. In Table 4.5, both amounts are listed. A third column, All Arts, was obtained by adding the first two.

Local variables Other sociological local variables include proportion of population over 50 years of age, proportion of the households with income higher than $50,000, and cost of living in the Beach (see Table 4.6). This information was gathered from the annual Sales and Marketing Management Surveys of Buying Power collected and published by Bill Communications, and from the CPI detailed report as published by the Bureau of Labor Statistics for the years of the study. One problem encountered in the data for the age demographics of Miami Beach was an abrupt

Table 4.5 **Local Incentives to Cultural and Recreational Activities (in million \$; real term 1982=100)**

Year	Cultural Affairs	Preservation and Development	All Arts
1977	2.38	0.73	3.11
1978	2.21	1.05	3.27
1979	2.05	0.96	3.01
1980	2.41	1.15	3.56
1981	2.41	0.97	3.38
1982	2.15	1.03	3.17
1983	2.28	1.10	3.38
1984	2.70	1.30	3.99
1985	3.13	1.91	5.04
1986	3.42	0.81	4.23
1987	3.40	0.90	4.31
1988	3.68	1.86	5.53
1989	3.07	1.95	5.02
1990	2.98	2.24	5.22
1991	2.69	1.92	4.60
1992	2.63	2.79	5.42
1993	2.74	3.12	5.86
1994	2.80	3.40	6.20
1995	2.35	2.99	5.34

Source: City of Miami Beach Annual Budgets.

change from one year to the other (i.e., in 1990 the proportion was 69% and the next year it was 44%). To smooth this series, a quadratic trend proxy was used. An exponential and a linear trend were also estimated but the quadratic outperformed them in terms of mean absolute error, standard error and R-squared.

Table 4.6 Miami Beach Demographics

Year	Population 50 + (%)[a]	(%) Pop. $50K+[a]	Median Income [a]	Crime Rate [b]	Commercial Rate Rent [c]
1977	72.50	7.8	8,009	8,169.8	63.1
1978	73.20	8.7	8,823	8,406.5	63.7
1979	73.56	9.1	9,326	9,298.3	68.2
1980	73.59	10.9	10,664	11,581.8	73.0
1981	73.29	11.2	10,739	10,820.4	90.8
1982	72.60	9.3	12,028	10,289.4	100.0
1983	71.71	6.7	11,215	9,512.8	100.8
1984	70.41	8.3	12,586	9,893.3	102.7
1985	68.79	9.2	13,409	11,270.1	104.2
1986	66.83	10.3	12,665	11,500.0	107.2
1987	64.54	11.2	13,194	12,386.8	109.8
1988	61.93	11.9	13,854	13,000.0	112.2
1989	58.98	11.3	13,134	14,012.1	120.9
1990	55.70	12.3	13,986	13,500.0	121.8
1991	52.09	13.3	14,859	12,786.1	126.1
1992	43.88	13.1	16,138	12,336.4	132.5
1993	39.27	13.0	15,858	13,500.4	139.9
1994	34.33	15.4	17,323	12,029.0	145.4
1995	44.00	14.0	17,800	12,319.2	156.6

Sources: *[a] Sales and Marketing; [b] Uniform Crime Report; [c] Statistical Abstract of the United States, US Bureau of the Census.*

Crime Figures on crime index per 100,000 habitants (not including arson) were gathered from the FBI Uniform Crime Report (see Table 4.6). Florida did not report such figure in 1986, and it was extrapolated (Greene, 1996).

Travel variable Airline fare price index for all urban consumers as estimated by the CPI detailed report will be used as indicator of the cost of traveling.

Income This variable will account for the income of domestic travelers coming to Miami. According to the Visitor Profile and Tourism Impact report published by the Greater Miami Convention & Visitors Bureau, New York has remained the major market of tourists for Miami and the Beaches for the last decade. It accounts for 30% of all domestic visitors. Information on median income for the New York metro area was collected from the Sales and Marketing Management Survey of Buying Power.

Space Figures for the cost of commercial rental rates for the Miami/Ft Lauderdale area were gathered from the CPI detailed report.

Image A dummy variable was created to indicate any major occurrence or event in Miami Beach caused by the arts sector. The years 1978, 1979 (Art Deco Movement), 1983 (Christo Wrappings), 1984 (Miami Vice first episode, admittedly a for profit event too significant to discard), 1986 (opening of the Miami City Ballet), 1987 (re-opening of the Colony Theater), 1990 (opening of the Lincoln Theater) and 1992 (Pavarotti's concert) were given a " 1" value. All the other years were indicated as " 0" to represent bad news or no news (no publicity) for the city. These events account for the perception people have of Miami Beach (an exogenous factor) and not for the decision of a particular arts organization to program these events (an endogenous factor).

X-Rate According to the Greater Miami Convention & Visitors Bureau's Visitor Profile and Tourism Impact, for the last twenty years, international tourism has mainly come from countries like

Venezuela, Brazil and Jamaica. In fact, one third of all international visitors (1.9 million) comes from South America. To illustrate the effect of international tourism, I took the exchange rate of a country whose economic conditions were relatively normal during the nineteen years of the study. Venezuela's exchange rate (B$:US$) for 1977-1995 was gathered from the Venezuela Country Profiles published by the Economist Intelligence Unit. The use of this variable will assume that the exchange rate responds to inflationary forces from both countries.

Tourist Satisfaction The city of Miami Beach does not keep records on tourist satisfaction. This missing variable in the empirical formulation may give room to specification errors. (See section on improvements at the end of the chapter.)

Functional Form and Other Empirical Considerations

There is no theoretical foundation for believing that the relationship in equation 4.10 is best fit by a linear representation rather than a semi-log or double log one. Different functional forms were run and compared. The double-log functional form works better for this data and model.[17]

Before estimating the model, however, there is one more empirical issue to be taken into account. The analysis of time series data assumes that the figures to be estimated are stationary or cointegrated. If the data is nonstationary, it is said to have an integrated component, and it should be differenced before or during the estimation process. The problem is exemplified by the yearly series on real output in the United States or any other macroeconomic data, that as a rule, are integrated. In regressions involving the levels of such data, the standard significance tests can be misleading. The conventional F and t tests would tend to reject the hypothesis of no relationship when, in fact, there might

be none. This situation also explains the high R-squared values that are obtained in most time-series models. In the case of the data for this study, by looking, for instance, at the behavior of the exchange rate, crime rate, and the percentage of the population 50 years of age and over we could appreciate a definite upward or downward trend for most years of the period to be studied. This situation could lead us to reject the hypothesis of no relationship (Ho) too quickly. There are several tests that can be used to determine whether a particular series is nonstationary or not. The Augmented Dickey-Fuller (ADF) test, for example, consists in running a regression of the first difference of the series against the series lagged once, lagged difference terms, and optionally, a constant and a time trend. In our case, there is no specific theory that explains the behavior of most of our variables, but there is an obvious trend for most of them. The ADF test with a constant term and time trend included assumes a random walk with or without drift and fits such series with obvious trends. For series without such obvious trends, the ADF test will assume a constant with no significant trend.

One of the limitations of all these tests is their low power, or their tendency to accept Ho too often. This low power is aggravated in the case of this study due to the small sample that was collected (n=19). All of these tests construct their own t-tables to determine the level of significance and rely on samples larger than 25 years. That may explain why five of the variables (exchange rate, space, crime, age fifty and over, and tax activity) turned out to be nonstationary when the ADF test was applied to the series. One solution to this situation could have been to increase the sample size, but data availability for all these variables is rather difficult, especially when the City of Miami Beach itself started formally collecting data of their own activities in 1983. Given the limitations of the test and the nature of the data, I proceed to run my regressions without differencing my series but fully knowing that I should exercise caution when interpreting my

results and that a necessary extension of the study requires a larger sample and careful consideration of the issue of stationarity.

Results

The model with the All Arts variable as the local incentive gave coefficients that were not statistically significant. Two other regressions were run, separating the destination of the All Arts funds. One model was run using only Cultural Affairs funding (money allocated by the City of Miami Beach to cultural events, performing arts programs, recreation, and the Bass Museum) and the other using only Development and Preservation funds (funds allocated for historic preservation, code enforcement, planning and development). The first run of these regressions indicated that some of the variables were not significant and/or that their t-value was less than one. These variables were removed from the model. The results of the second run of these two regressions are summarized in Table 4.7 and 4.8.

The results suggest the additionality of local incentives to cultural affairs, performing arts programs, recreation and the Bass Museum. These funds have had a significant impact on the development of the Miami Beach area. The case is different for funds allocated to Historic Preservation and Development. It may very well be that these government funds could be managed and used in a more efficient manner or could be reallocated in some other sector of the local economy. As it was described before, for the last 20 years the city has been constantly changing, opening and re-structuring their Preservation department and policies in order to respond to real estate developers that claim that historic preservation is bad for development. Moreover, since our conceptual model joined "the arts" and "historic preservation" and assumed these groups had similar goals, some legal and political elements were not included in the analysis. For instance, in 1994, some property assessments in the Art Deco District went

up as much as 300% to 400% (Tourism and Cultural Commission, 1995). Most of the increased assessments were in the value of the land. Five to six sales in one sector of the District affected the assessments. If a property increased in market value, assessments also increased which in turns created market pressure to tear buildings down. This revaluation approach appears to be in conflict with the preservation rationale. The assessment process used places most of the value of the property in the "highest and best use" of the land rather that in the building. Several alternatives are available: property tax abatements for owners of historic buildings, tax deferrals, tax credits, assessments based on use rather than on just value. In the case of Florida, an ad valorem tax exemption for historic property owners developed as result of the 1992 constitutional amendment. In 1998, a state law was passed offering a 50% tax break to owners of commercial historic districts. Problems arise due to the nature of the political system in the United States. The cities and the counties are given free range of motion to decide how and when they are going to implement these changes. To improve this study, we could model this process and describe how it affects the real estate market, economic development and the agents involved (i.e., historic property owners, property appraisers, local government, surrounding property owners, and taxpayers).

The *image* coefficient is statistically significant in both regressions and suggests that the actual cultural activities performed in Miami Beach and the public space they create do increase the level of tourism. The coefficients for the proportion of residents with income above $50,000 were positive and significant in both regressions which suggests that a percentage change in this proportion affects positively tourism, as expected. As the population of the city gentrifies, the area becomes safer and more appealing to visitors. Similarly, the results show that as the proportion of people 50 years or older decreases tourism increases - once again, gentrification.

**Table 4.7 Regression Results. Miami Beach Development
Local Incentives to Arts, Cultural Affairs,
Recreation and Bass Museum**

Dependent Variable: RESORT (log)
Sample (adjusted): 1978-1995
Included observations: 18 after adjusting endpoints

Variable	Coefficient	t-Statistic	Probability
Constant	15.26	20.095	0
Image	0.093	4.898	0.0005
Age	-0.605	-3.788	0.003
Above $50K	0.285	5.157	0.0003
Cultural Affairs	0.128	1.965	0.0752
Trend	-0.049	-8.496	0
X-rate	0.153	4.903	0.0005

R-squared	0.984	Mean dependent var.	15.261
Adjusted R-squared	0.975	S.D. dependent var.	0.167
S.E. of regression	0.026	Akaike info criterion	-6.998
Sum squared resid	0.007	Schwarz criterion	-6.643
Log likelihood	44.40	F-statistic	113.924
Durbin-Watson stat.	2.698	Prob. (F-statistic)	0

The coefficient for the *exchange rate* is statistically
significant for the regression on Table 4.7 but has a
counterintuitive sign. The positive sign suggests that as the
Venezuelan currency (Bolivar) devaluates in terms of the dollar,
Miami Beach experiences a percentage increase in its level of
tourism activity. This counterintuitive result may suggest that
international tourism is a more complex situation than the one

suggested here. We have to take into consideration the social and economic characteristics of international tourists that arrive in Miami Beach, the political situation of the country, and any economic shock that this country may have experienced in the last 19 years.

Another suggestion is creating a weighted exchange rate for South American countries in terms of the numbers of visitors

Table 4.8 Regression Results. Miami Beach Development Local Incentives to Development and Historic Preservation

Dependent Variable: LOGRESORTCPI
Sample (adjusted): 1978-1995
Included observations: 18 after adjusting endpoints

Variables	Coefficient	t-Statistic	Probability
Constant	27.00	12.38	0.00
Image	0.14	4.71	0.00
Age	-1.36	-6.46	0.00
% above 50K	0.21	2.50	0.03
Income New York	-0.65	-3.35	0.01
Devp't and Preservation	-0.10	-2.26	0.05
Trend	0.00	-0.26	0.80
Space	0.28	1.01	0.34

R-squared	0.98	Mean dependent var.	15.26
Adjusted R-squared	0.96	S.D. dependent var.	0.17
S.E. of regression	0.03	Akaike info criterion	-6.56
Sum squared resid	0.01	Schwarz criterion	-6.16

from each of these countries. Detailed data series for this weighted average was not available for most of the years of this study. Furthermore, this method only exacerbates the difficulties encountered with the current empirical variable. When countries like Brazil and Venezuela are put together we are assuming similar social and economic conditions in both countries. This assumption would be very difficult to support.

The *income variable* used to account for domestic (New York) tourism was statistically significant and had the expected sign in the regression in Table 4.8. For the equation using the Cultural Affairs variable, an alternative was used, namely real per capita income, but the results were quite similar. Again, we may have to determine the exact geographical location and socioeconomic conditions of the New Yorkers visiting Miami Beach. The empirical variable used to measure income of domestic tourism may be too broad.

Space, crime and airfare performed consistently poorly in almost all the regressions run maybe as a result of the data being nonstationary. The output of the Durbin-Watson tests for both models indicates no autocorrelation and the R-squared and F-statistics indicate some relation among the dependent and independent variables. The results indicate that the image of the city and the funds spent on cultural affairs do improve the economic conditions of Miami Beach. Nonprofit arts organizations may be right when asking for more direct funding from the City. Funds on development and heritage may have been misused due to the conflictive political interaction among preservationist, developers and local officials. Gentrification is, as expected, a prerequisite for economic revitalization.

Improvements

1) The conceptual model could be improved by studying the effects of the weather on tourism, and by analyzing business-related tourism to the city of Miami Beach.

2) The empirical estimation should include a more specific rent variable, conduct a survey on tourism needs and satisfaction for the city of Miami Beach, and include a better formulation and measurement of the international tourist market.

3) Even if an expanded study finds support to show that government incentives to cultural organizations and heritage promotes local development, the additive effect criterion is only a necessary but not sufficient condition for an incentive offer. The criterion does not consider the additional requirements that the benefit of the additive effect exceed the incentive's cost. An interesting extension would measure the benefits of local economic development against incentive costs.

Notes

[1] Excluded from this analysis is the "high-tech information" sector. For a study of the impact computer networks and new communication facilities are having in urban planning see Fox-Przeworski, 1991.

[2] In fact, it is argued that I-95 killed the Black community as well!

[3] The Historic Preservation Fund consists of Grants on a 50% matching basis that are issued to States, the District of Columbia, Territories and the National Trust. Funds may be used for surveys of the State for historic properties, preparation of historic preservation plans, preparation of nominations to the National Register, and acquisition and preservation of properties listed in the Register. At the discretion of the Secretary of Interior, grants up to 70% of cost of survey and planning and acquisition and development projects. Funds may be transferred by State Historic Preservation Officers to private organizations, individuals or governmental subdivisions. The Department of the Interior also provides

grants for Urban Parks and Recreation Recovery Programs, Endangered Properties, and Consultant Services for Preservation Affairs.

[4] See Raley (1994).

[5] See Appendix B for a demand study for the NWS.

[6] See Hansmann, 1987 for more on the modeling of nonprofit arts organizations.

[7] A nice extension to this study would be to model the legal implications associated with this process.

[8] See Becker (1996) for a discussion on acquired taste.

[9] See Chapter 4 for a brief discussion on quality measurement in the arts.

[10] When determining the exogenous and endogenous variables of these model, we only take the factor price of inputs as exogenous.

[11] See Hansmann, 1987, on the relationship between donations and quality; see Pignataro (1994) on the validity of these measures and their relationship to quality.

[12] Hansmann, 1987, assumes donations from individuals vary inversely with price.

[13] A nice extension will study the determinants of business and convention-related visitors.

[14] See Section 3.4 for ways to measure this variable.

[15] A nice extension to the study would be to include the negative impact of extended tourism in terms of all the local resources used to satisfy the tourists needs.

[16] The Greater Miami Chamber of Commerce conducted once such survey in 1993 but has no current plans on conducting them again.

[17] As Greene (1993) points out, some regressions perform well even when a priori we know they are misspecified. A linear, semi-log, and double-log forms were run. A Pe test (or modified J test) was conducted to determine the validity of the specification of the model (Greene, 1993). The Pe test can be used to test the following hypothesis:

$$H_0: y = h(x, b) + e_1 \text{ versus } H_a: g(y) = H(z, f) + e_2$$

where x and z are regressors, b and f are the parameters, and e are the error terms. For this test, both h(.) and H(.) are linear, while g(y)=ln y.

Let the two competing models be denoted

H_O: $y = x'$ $b + e_1$ and H_a: $y = \ln (x)'$ $f + e_2$.

Let b and c be the two linear least squares estimates of the parameter vectors. The P_e test for H_a as an alternative to H_o is carried out by testing the significance of the coefficient a in the following model

$y = x'$ $b + a$ $\{\ln y - \ln (x'b)\} + e$.

The second term is the difference between predictions of y obtained directly from the log-linear model and the ones obtained as the log of the prediction from the linear model. Basically we are going to test whether a is statistically significant. If it is, we would be providing support for the use of the logarithmic form. If it is not (i.e., a = 0) then we would be saying that the model is specified just fine with the linear terms. The estimates of a obtained for testing the linear versus the double log form (ALL ARTS as the variable for local incentives, for example) is - 2818496. Its t-value is -2.40. Referring this value to the standard normal table, I reject the linear model in favor of the double log form.

5 Conclusion: New Urbanism and Cultural Coalitions

The theoretical analysis and research of cultural activities have been limited, for the most part, to the study of the role of government in the nonprofit arts sector. The tools used by economists, urban planners and policy makers to evaluate this intervention follow a macroeconomic perspective and fail to account for microeconomic principles and assumptions that determine the outcome of such interventions. This book attempted to formally model the microeconomic behavior of the agents involved in artistic activities, how and why the form cultural coalitions, and the effect they have on different sectors of the economy. This model gave culture a limited role in processes of economic redevelopment and emphasized instead the importance of cultural coalitions in the re-creation of the public space of a blighted community.

A similar model could be used to evaluate the impact of a different type of pro-city coalition: New Urbanism. In America, "New Urbanism" refers to the coalition of architects, planners and city officials who wish to change current zoning and land use laws to allow for denser kinds of development (see Katz, 1994; Ellin, 1996). These coalitions have taken the form of "social movements" and aim at showing that it is still technically possible to build towns with a conventional pedestrian-friendly configuration based on streets, sidewalks and building blocks. These projects are promoted as safe and attractive neighborhoods where a family can find all it needs at a walking distance. Two major examples are similar projects taking place in Kendall and Seaside,

101

Florida. We can also find elements of New Urbanism in places like summer camps, residential college campuses, retirement communities and Disney World. These coalitions are, however, often criticized as being out of touch with the needs for globalization, the information age, and the trends of regionalization. The lack of understanding of how these coalitions work has led many critics to believe that this movement can actually go unchecked and become authoritative. It is argued that these coalitions will have the power to dictate the type and nature of the recreation facilities, cultural activities, retail shops, and landscape offered to the community. These powerful coalitions would even take on the responsibility to coordinate with the local government vital issues like education, provision of utilities, police and fire protection, and zoning ordinances.

At the moment, there is a high degree of imprecision in the academic discussion of the scope of New Urbanism, and its impact on social and ethnic order, architectural design, zoning designation, cultural funding, and the environment. The validity of the criticisms to this type of coalitions and the assessment of its impact can be evaluated by analyzing the characteristics and motivations of the members that form this movement. As we saw in the case of Miami Beach, a conceptual model that explains how the coalition members interact with each other may help us understand how these intended or unintended groups work to support their own efforts and cancel out private agendas that work against the goals of the coalitions. This model could also serve as the foundation for an empirical study to bring light on the issue of how efficient these new Urbanism plans are, how they affect the economy and how well they fare in the new global economy.

Appendix A

Marketing Cultural Tourism

The following is a list of marketing issues and strategies gathered from studies on Cultural Tourism by Van Tuyl (1996), the Port Authority of New York and New Jersey, the SRI Research group, and the Florida Department of Commerce.

Market Characteristics

- For the most part, "historic" visitors are highly educated and strongly believe advertising has no impact on their buying decisions. It seems clear that those messages which are perceived as informative rather than persuasive will be more influential. High levels of education imply a reasonable level of literacy and reading comprehension. Surveys indicate that historic visitors are less likely that other visitors to learn about historic sites from television, newspaper, magazine and radio advertisements.
- For many visitors, authenticity of historic experience may not be an issue of interest. In fact, there may be some appeal to history that is "neater", more orderly, more readily consumed than in authentic sites.
- Surveys tell us that visitors are motivated to see the "right things" and to see them in an efficient way that does not waste time. However the same surveys indicate that tourists do not like to be told that they are part of a prepared tour.
- Cultural visitors will travel long distances to attend performances of unknown pieces of popular playwrights or

composers. Festivals, series, workshops and seminars are the cost-efficient way of engage in fulfilling cultural tourism.

- The cultural visitor will be looking for more sophisticated mementos, perhaps items that approach in their artistic or literary authenticity the historic or cultural sites tourists have visited.

- Cultural visitors will not be attracted to "discount", "lowest price", or "free ticket" deals as the perceived value of cultural products decreases significantly with such promotions. On the other end, increasing the value of the cultural activity by offering discounts to fine restaurants and selected retail shops in town has better results.

- Historic visitors consider that actual visits to historic sites with children are an important way that children can learn values. Special tours for children, playgrounds and controlled child care at historic sites could appeal to these visitors.

- Familiarization trips, sales calls, trade shows and seminars are successful marketing techniques to attract both buyers and suppliers of cultural tourism.

- Potential advances in information technology could alter operations within the industry. For example, airline tickets purchased through vending machines at local supermarkets may soon be a reality. On-line demand for information about specific travel destinations, weather forecasts, crime statistics, special events calendars, museum holdings, and restaurant and hotel ratings may rearrange the industry structure in terms of who develops, provides and gets paid for information. The impact of technology improvement and information accessibility would be larger on the market of cultural and historic visitors that tend to have direct access to computers and the Internet.

- Surveys reveal that cultural and historic visitors value significantly historic visits that are environment-based. In fact, travelers would rather visit an area where both city and seaside

or countryside are easily reached than varied stimulating city environment.

Cultural Coalitions

- Most city officials and business owners have a difficult time identifying themselves as part of the Cultural Tourism industry. This lack of identification occurs, in part, because the primary source of revenue for most cities is local residents, not visitors. In many instances, these city officials and business owners do not have information about the importance of the tourism industry which in turn reduces their incentives to change their policies and marketing strategies. Something as simple as distributing reports with basic economic indicators of the tourism industry to business leaders and cultural tourism can be the best starting point of a successful marketing campaign. Assuming that this information is already known could prove to be a costly mistake.

- Lack of information on this issue creates fragmentation within the community which in turn translates into overlapping mandates, jurisdictional jealousies, political infighting, and ad hoc planning and marketing efforts. Coalition initiatives are being developed in the face of declining resources. Several states have begun to dedicate specific revenue sources to fund travel promotions and research. Extensive education, public relations and research programs serve as valuable sources of information and provide liaison support between the travel industry and state officials. Coalitions of this type have proved successful in the United Kingdom (West Country Tourist Board) and the United States.

- The Virginia Commission on the Arts and the Virginia Tourism Corporation are collaborating to help arts organizations develop tourism promotion efforts. Arts organizations are eligible to apply for grants from the arts

commission to market their organizations. A key component of this project is its focus on partnerships. A minimum of three organizations must partner together for funding under this program and can include destination marketing organizations, private businesses, chambers of commerce and other groups. Another facet of the marketing collaboration between the arts council and the state tourism agency is providing a free Web presence for the state's cultural organizations.

- The Tennessee Arts Commission, the Virginia Commission for the Arts, and the North Carolina Arts Council received in 1997 a $225,000 grant from the National Endowment for the Arts to plan, develop and market two heritage tourism trails that highlight traditional music and Cherokee arts and culture. When completed in the year 2000, these trails will be linked to the Blue Ridge Parkway and will guide visitors to the extraordinary musical, artistic and cultural traditions of this mountainous region. These projects will serve communities that want to highlight their own cultural heritage as an economic development strategy.

- New Jersey recently formed a Cultural and Heritage Tourism Committee formed by the New Jersey State Council on the Arts and the State's Division of Travel and Tourism. The committee has released a framework for a special Cultural and Heritage Tourism Initiative to identify and develop package tours which feature cultural and heritage attractions; create an integrated Year of Cultural and Heritage Tourism campaign focusing on New Jersey's cultural attractions; encourage active participation in and ownership of the Cultural and Heritage Initiative; and establish an on-going program to support, nurture and encourage cultural and heritage tourism.

- Representatives from the California Council on the Humanities, the California Arts Council, State Historic Preservation Office and the California Division of Tourism formed a working group to launch a statewide effort to

stimulate cultural tourism. The group plans to collect and analyze information on how cultural tourism is measured in existing research; develop a set of core values; include six cultural tourism representatives on the state marketing advisory group; and develop a strategy for funding a cultural tourism marketing and development program.

- The Iowa Arts Council is collaborating with the Iowa Division of Tourism to organize and promote "the Iowa Collection". This collection will reflect the state's rich history and diverse population. The partnership offers Iowa artists an opportunity to create new work or highlight existing work, and promotes the arts as an important part of Iowa's tourism industry.

- A trio of local arts agencies, three convention and visitor bureaus, Hyatt Hotels and the California Division of Tourism recently formed The California Arts Council. The group plans to market San Diego, Los Angeles and San Francisco through promotion of their arts and culture. With $150,000 in seed money from the National Endowment for the Arts, the partners have committed to matching this grant with $450,000, which will be used to develop brochures and other materials outlining 16 different itineraries. Each itinerary will highlight cultural attractions, as well shops and restaurants within each city, and encourage visitors to visit the other cities in the project since the themes will be common to each city. Each brochure will be printed in four separate languages: Japanese, German, Spanish and English. They will be distributed to travel agents and tour companies nationwide and abroad. The consortium expects to ultimately raise $1 million for the campaign and will add a major airline, credit card company and rental car agency to strengthen this public private venture.

- The Atlanta Convention and Visitors Bureau (ACVB) will spend $1 million a year to promote the city's artistic and cultural offerings. To persuade visitors to stay another night, the ACVB will launch an aggressive program entitled "Culture

Front and Center" that will assist local arts organizations in expanding audiences and fundraising sources. A marketing strategy has been designed to include hotel and tour packages, a Web site and a unified marketing strategy for the more than 100 Atlanta arts organizations.

Appendix B

Cultural Demand

The New World Symphony (NWS), located Miami Beach, Florida, is a music school that trains young musicians from all over the world. Their goal, or objective function, is to prepare young musicians to perform in larger organizations, and to bring music to the community. They organize mentoring programs for high school students and free concerts for the community. Its house, the Lincoln Theater, is rented frequently to other smaller arts organizations at a very low rate (if not free).

To make the education of their students more comprehensive, the NWS organizes a yearly series of concerts and music exchanges. Through a very successful public relations campaign, an international pool of applicants, and the artistic direction of the worldwide known composer Michael Thomas, the NWS has earned the image and the reputation of being a "serious" symphony of greater quality than the Florida Philharmonic even when they are "only" a school. In the last few years, their concerns have shifted from promoting themselves as a worthwhile symphony to spreading their music to as many people as possible. The NWS showed this commitment, for instance, when they re-structured their Marketing and Public Relations department during the 1992-93 season (which the NWS considered a "slow" season after a campaign that relied on complementary tickets to boost up attendance). Since the number of attendants was not increasing as they expected, the department hired a new vice-president in late 1994. In the spring of 1996, the Marketing and Public Relations department became two separate and independent units. One of the major findings, if you will, of this process was the lack of

coherent, straightforward reports on attendance and ticket revenue. Creating such reports, a set of data on attendance was obtained. For the 1990-91 to the 1995-96 seasons, the same seven concert series were selected. Each series has different numbers of concerts scheduled, ticket prices, different number of guests and players, and different locations with different capacities (Lincoln Theater and Gusman Center). The information gathered provided the NWS with a pooled set of data for seven different events for the last six years (Table B.1). Additional exogenous local market and environment characteristics were gathered and shown in Table B.2.

Conceptual Model

The effects of a vector of prices, income and other market characteristics on attendance to cultural events will be discerned in this section. First, a conceptual model needs to be formulated to provide guidance for carrying out the empirical work. This model provides the basis for selecting the explanatory variables to be included in the analysis. It also helps avoid omitting important variables (and the biased coefficients associated with it).

First, it will be assumed that attendance to the NWS is affected by the factors determining the behavior of the firm and the consumers. Formally,

Attendance = f (Supply-determining factors, Consumption-determining factors). (B.1)

We now proceed to model the behavior of the NWS and its consumers.

**Table B.1 NWS Ticket Prices and Attendance
1990-1996**

All Prices expressed in real terms 1982=100

Events	90-91	91-92	92-93	93-94	94-95	95-96
Opening Attendance	1197	1074	926	905	816	590
$	145.05	139.8	127.37	123.42	99.49	96.28
Gourmet Attendance	937	990	583	344	339	380
$	121.2	116.52	105.68	102.42	118.91	115.16
Interludes Attendance	724	836	743	729	745	694
$	72.5	82.34	88.61	83.6	83.36	89.75
Intermezzo Attendance	620	876	602	734	662	668
$	87.5	101.36	118.07	137.29	142.47	146.29
Crescendo Attendance	760	810	711	602	690	488
$	105	122.78	141.68	114.41	119.56	125.54
Chamber Attendance	189	109	126	115	155	242
$	48	46.2	44.89	43.5	41.89	39.84
Family Attendance	903	263	350	345	493	319
$	16.5	15.89	15.43	14.95	14.4	16.19

Source: NWS Annual Reports.

Table B.2 **Demand Determining Factors**
 New World Symphony 1990-1996
 (real terms 1982=100)

Variables	90-91	91-92	92-93	93-94	94-95	95-96
Households with income >$50K	20.9	23.7	23.7	23.8	28.2	28.4
Restaurant Prices ($)	15.7	16.8	17.8	18.2	19.2	20.5
Ballet Price ($)	120	117.48	115.59	113.17	110.62	107.02
Population Market of Households with $50K+	276.2	294.2	297.7	301.3	358.7	368.6

Sources: See Section "Variables Used"

The Firm

It is safe to assume that the NWS has multiple goals.[1] To model its behavior, the major tools to accomplish all these goals should be analyzed. The NWS chooses the location of their performances, the number of concerts, quality and prices, letting the market or the interplay of supply and demand choose the equilibrium quantity or attendance value.

1) Assuming that both locations are available for all concerts, the NWS chooses the location of performances at either the Gusman Center or the Lincoln Theater (denoted LOCATION). This decision will be positively related to concertgoers' preferences for a particular hall due, for instance, to any complementary amenity the hall may provide (denoted

PREFERENCES). The Acoustic facilities will positively influence the choice of one hall over the other (denoted ACOUSTICS).[2]

The location decision will be negatively related to the rent rate of the hall ($HALL_{RENT}$), and positively related to past attendance to a particular theater ($ATTENDANCE_{-1}$) assuming habit formation (Becker, 1996), and lastly hall capacity ($HALL_{CAPACITY}$). Formally the location equation is represented as,

Location=f (Preference, Acoustics, $Hall_{RENT}$, $Hall_{CAPACITY}$, $Attendance_{-1}$). \qquad (B.2)

2) Once the location decision is made, the number of concerts is chosen. In each series, the number of concerts (CONCERTS) will be positively linked to the subscription price ($PRICE_{SUB}$), and the amount of individual donations ($DONATIONS_{-1}$), as an increased amount of donations would provide more resources to program more concerts. The lagged response is explained as the NWS makes decisions on programming and events, and start to incur in costs of printing, and scheduling auditoriums in advance. They look at the donations from this year and determine how this would affect their programming for next year.

The number of concerts will be inversely related to the cost of putting together a concert (COST). When determining the exogenous and endogenous variables of these models, we only take the factor price of costs as exogenous. Formally,

Concerts = f ($Price_{SUB}$, $Donations_{-1}$, Cost). \qquad (B.3)

3) The NWS chooses the level of concert quality (QUALITY) it will offer to the subscriber. This variable will be positively linked to subscription prices ($PRICE_{SUB}$), individual donations ($DONATIONS_{-1}$) (see literature review and Hansmann (1987) on the relationship between donations and quality), number

of concerts in each series (CONCERTS) (as we assume that quality, as perceived by the consumer, increases with the number of concerts), and cost of concert (COST) (see Pignataro (1994) for the validity of these measures and their relation to quality). ACOUSTICS, fame and experience of conductor (CONDUCTOR), and fame and experience of soloist (SOLOIST) will positively influence the quality of the concert. This variable is also positively related to the performance of the full orchestra (FULL) while negatively related to chamber orchestra, (i.e., four to eight musicians at most), (CHAMBER). Formally,

Quality= f (Pricesub, Donations$_{-1}$, Conc, Cost, Acoustics, Conductor, Soloist, Full, Chamber). (B.4)

 4) Now the NWS is ready to choose the subscription price for all their events (PRICE$_{SUB}$). They will take into consideration the size of the concert hall, either the Lincoln Theater or Gusman Center, (denoted HALL$_{SIZE}$); and the size of their potential market, defined as amount of households earning more than $50,000 a year, (denoted INCOME). The price charged will be positively related to the cost of the concert (COST); advertising expenses (ADVERTISING); and negatively related to individual donations (DONATIONS). (If Hansmann's supposition about the voluntary price discrimination behavior of patrons is correct (see literature review), donations from individuals would vary inversely with ticket prices). QUALITY and CONCERTS will positively affect the price variable. Formally,

Price$_{SUB}$ = f (Hall$_{SIZE}$, Income, Cost, Advertising, Donations$_{-1}$, Concerts, Quality). (B.5)

The Consumers

1) The consumer has to choose between NWS concerts and any other cultural activity. (SUBSCRIBE). This decision is negatively linked to the subscription price of all NWS series ($PRICE_{SUB}$) and the traveling distance from home to the concert hall for the different cultural options (DISTANCE). It will be positively related to the subscription price of a substitute entertainment ($PRICE_{ENT}$) and the consumer income (INCOME); and negatively related to the price of a good that complements the cultural outing ($PRICE_{COMP}$). The perceived quality of the NWS relative to the other cultural goods (PERCEIVED) will be positively related to the decision to subscribe to the NWS events. Formally,

Subscribe = f ($Price_{SUB}$, Distance, $Price_{ENT}$, Income, $Price_{COMP}$, Perceived). (B.6)

Once the consumers have decided to subscribe to the NWS, they have to choose to which series to subscribe (SERIES). This decision will be negatively related to the subscription price of a series ($PRICE_{SUB}$). Series quality ($QUAL_{SER}$) may result in greater attendance; however, "high quality" performances may have limited appeal. Then, the effect quality has on subscription could not be determined a priori. The subscriber may tend to subscribe to the series with higher number of concerts (CONC) and may tend to have a location preference (PREFERENCE). Finally, the amount of advertising spent on each series will positively affect number of subscribers the same way that a previous pleasant concert experience (PREVIOUS). Formally,

Series = f ($Price_{SUB}$, Income, Preference, $Quality_{SER}$, Conc, Advertising, Previous). (B.7)

In the case of nonprofit arts organizations, concertgoers have another choice: they can voluntarily donate money to the NWS.[3] Individual donations to the NWS (DONATIONS) are going to be affected by the price of giving. Specifically, this price will be defined as the amount of money of charitable contributions that can be deducted, as opposed to the different bracket rates in which the contributor may fall. This price is in turn determined by state and federal tax rates and changes in those rates. For this particular study, this variable would be dismissed as federal income tax rates "rules" have not been changed for the period of this study (as the Internal Revenue Service reports in their "Itemized Deductions" publications), and there are no state income taxes in the state of Florida. Nonprofit organizations frequently spend large amounts on fund raising activities. Whether these expenditures should be considered as part of the price of giving has been a source of debate (Weisbrod, 1988; Steinberg, 1986). According to Luksetich and Lange (1995), the ratio of the amount spent raising funds to the funds raised is a commonly applied measure of efficacy of fund-raising efforts. A better measurement could be the ratio of the prior year fund raising spending to donations received. Other factor affecting positively the amount of individual donations is the income of the concertgoers (INCOME), the perceived quality of the NWS (PERCEIVED), and the amount the NWS spends on public relations (PR). Increased number of subscribers (# OF SUBSCRIBERS) may increase the pool of potential donors. At the same time, it may provide non-contributors greater anonymity and thereby increase the ability of potential patrons to free ride on the donations of others. This could reduce donations. Of course, orchestras can increase the cost of free riding by providing the donors with choice seats and other perquisites (PERQUISITES). Finally, as subscription prices increase (PRICESUB), one would expect donations to decrease. Formally,

Donations = f (Development, Income, PR, Perceived, # of
Subscribers, Perquisites, Price$_{SUB}$). $\hspace{3cm}$ (B.8)

Structural Equations

$\hspace{2em}$This behavioral model leads to the following structural
equations:

Demand = f (Price$_{SUB}$, Distance, Price$_{ENT}$, Income, Price$_{COMP}$,
Perceived, Location, Quality$_{SER}$, Concerts, Advertising,
Development, # of Subscribers, Perquisites, PR, Donations, Series,
Subscribers, e_1); and $\hspace{4cm}$ (B.9)

Supply= f (Preferences, Acoustics, Hall$_{RENT}$, Price$_{SUB}$, Hall$_{AVAIL}$,
Donations, Cost, Conc, Hall$_{QUALITY}$, Conductor, Soloist, Full,
Chamber, Hall, Income, Advertising, Attendance$_{-1}$, e_2). $\hspace{1cm}$ (B.10)

And the third equations as specified previously,

Attendance = f (Supply-determining factors, Consumption-
determining factors, e_3). $\hspace{4cm}$ (B.1)

where DEMAND refers to the factors determining the behavior of
cultural consumers, SUPPLY refers to the factors determining the
behavior of the NWS, Attendance is the attendance at the NWS
events, and e_is are unobservable random variables.
$\hspace{2em}$These structural equations describe the behavior of
economic agents, like the NWS. We could solve the above
equation for Attendance, Demand and Supply and obtain reduced-
form equations. In the reduced-form, each of the endogenous
variables is determined by all the exogenous and predetermined
variables. Since we are interested in studying the attendance to the
NWS, a reduced form equation will be estimated for Attendance
where on the right hand side we will have all the exogenous and

predetermined variables of the model. Since these reduced-form equations constitute a classical regression model, the ordinary least squares applied to them yields a consistent (but not always efficient) estimator of the coefficients. The tendency in the field of Cultural Economics is to hypothesize about this type of relation between attendance and price without using a conceptual model that could provide guidance for selecting the explanatory variables to be included in the model. Without such guidance, the researchers could hypothesize a relation and later run regressions based on it without knowing whether or not the right hand variables in their equations are endogenous or not. Such variables should not appear as explanatory variables unless specific techniques designed for estimating simultaneous equations are utilized. These functions have both endogenous and exogenous variables in our structural equations. For this model, the endogenous variables are $PRICE_{SUB}$, COST, CONCERTS, CONDUCTOR, SOLOIST, FULL, CHAMBER, ADVERTISING, LOC, DONATIONS, PR, DEMAND, SUPPLY and PERQUISITES. The exogenous variables are $INCOME$, $ATTENDANCE_{-1}$, $PRICE_{ENT}$, $PRICE_{COMP}$, PREFERENCES, ACOUSTICS, $HALL_{RENT}$, $HALL_{AVAIL}$, and $HALL_{QUALITY}$.
The reduced form equation to be estimated is:

$$Attendance = f (Income, Attendance_{-1}, Price_{ENT}, Price_{COMP}, Hall_M)$$
$$(B.11)$$

where $HALL_M$ is a vector of characteristics that differentiate the two halls at which the NWS performs.

Empirical Considerations

Variables used:

• Attendance: The number of subscribers for each series was gathered from data the NWS provided for the 1990-91 to 1995-

96 seasons. To account for population shifts in the Miami-Ft Lauderdale area (determined by looking at the zip codes of the subscribers), attendance was divided by the population of households with incomes larger than $50,000 as gathered from the Sales and Marketing Management's Magazine's annual Survey of Buying Power in market areas in the US from 1990-1996.

- Income: All the surveys the NWS has conducted indicate that most of their customers earn more than $50,000 per year. Instead of using measurement of incomes (median income, per capita income and its deviations) that have proven not to be satisfying (Luksetich and Lange, 1995; Gapinski, 1984), a proxy was used. Besides, it could be argued that any average market measure does not capture the effect of subscriber or attendee income on symphony demand. There is enough variation within a zip code, for example, that the average income of that area is not a good proxy for their income. Attendees to such events are such a small part of any market that the market measure probably does not capture adequately the income effect (see Luksetich and Lange, 1995). From the Sales and Marketing Management Magazine's survey, data on percentage of people who live in households with an income greater than $50,000 were gathered.[4]

- Price$_{ENT}$: To account for substitute good, the price of another cultural event in the Miami Beach area was used. The Miami City Ballet, located a few blocks from the Lincoln Theater, was considered suitable as the most recent attendance survey conducted by the New World Symphony during their 1994-95 season suggests that their clients patronize this institution more than any other large cultural event (23% of the NWS audience attends the MCB; 22% the Florida Grand Opera; 19% the Florida Philharmonic; 13% Concert Association).[5] These prices were corrected for inflation using the CPI for the

"Entertainment" category Urban/South/Population greater than 1.2 million.

- Price$_{COMP}$: To account for complementary goods, the price for restaurant visits in the Miami area was gathered from the Greater Miami Chamber of Commerce's Miami Profiles for the years of the study. These prices were corrected for inflation using the CPI for the "Food Away from Home" category Urban/South/Population greater than 1.2 million.

- Hall$_M$: To account for the differences in the two concert halls, a dummy variable is created: 1= Lincoln Center, capacity 789; 0=Gusman Center, capacity 1710.

Functional Form

Similar studies (Gapinski, 1985, 1984, 1981; Luksetich and Lange, 1995) have used, with no justification, OLS estimators for their panel data and assumed a linear form. To assess the need to treat the data as a longitudinal set, a regression was run assuming that all constants and intercepts were the same (classical OLS formulation) and made it the restricted model, and then proceeded to run it as a longitudinal set using fixed effects (see below) and made it our unrestricted model. In here, it is contended that the coefficients are the same but the constants are different. The test of these restrictions resulted in an F-value (6,23 d.f.) of 19.71 which provides evidence for treating this data as longitudinal set. A better formulation is then the longitudinal approach assuming either that differences across units can be captured in differences in the constant term (fixed effects) or that there is a component of errors that is individual specific (random effects model).

The fixed effects formulation assumes that there is no correlation across the residuals from the various subscription series. Following Pignataro (1994) and Throsby (1994), we could model consumption of symphonies at time t as positively dependent on time t-1. This addition to the formulation of the

model would acknowledge the "addictive" or "acquired taste" aspect of artistic goods (see Becker, 1996). This condition prevents us from using the fixed effects formulation. The random effects model becomes more appropriate since we are assuming that New World Symphony is not an outlier and behaves like most nonprofit Arts organizations.[6] The random effect treatment may suffer from the inconsistency due to correlation of the explanatory variables with errors. On the other end, some authors like Mundlak (1978) argue that individual effects should always be treated as random. The fixed effects model is simply analyzed conditionally on the effects present in the observed sample and prevent us from obtaining estimates of effects of variables that do not vary over time. It is also costly in terms of degrees of freedom. The random effect, in a wide, longitudinal data set, has some intuitive appeal and provides us with the simplicity of one intercept or constant.

This discussion of the appropriate functional form of a demand function assumes consistency in tastes and preferences and full or perfect information which are unlikely in the behavior of any consumer, let alone the cultural one (Pignataro, 1994). The conflicting assumptions do not end here. To formulate this functional form, the researcher must be able to "catch" all the factors that affect the demand for a particular good. In reality, when certain variables are not observed or when a variable is replaced by a proxy, the results are somewhat different. It has been observed, for example, that simple linear functions "outperform" forms like the Box-Cox function, and provide stronger more statistically significant coefficients than logarithmic functions even when these two different forms cannot be compared through their coefficient of determination. Taking this into account, a linear functional form will be used to obtain the empirical results. On the other end, it should be taken into consideration that when calculating demand functions, the formulation should reflect at least diminishing marginal utility,

which the linear form does not accomplish, and the double log form does.

Results

Different forms and models for the estimation of equation B.11 were run based on the mixed evidence that is found in the literature. The results are shown in Table B.3. Based on the standard significance tests, the best fit for this model is obtained from the fixed linear model even when its degrees of freedom are somewhat low (d.f. = 30). This model provides results where most of its coefficients are statistically significant at 5%, and has a high R-squared.

 The mixed results obtained from the random model suggest that the claim that the New World Symphony behaves like any other nonprofit Arts organization in the area is invalid. After all, the New World Symphony is one of the largest Arts organizations on Miami Beach, runs its own theater, and is much better organized and managed than most nonprofit Arts organizations. Previous attendance affects the dependent variable only when the random model is used which is not surprising as this model accounts for this addiction factor. In regards to the functional form used for the various models, the P_e test[7] was used. After computing fitted values for the pooled linear equations, the estimate for alpha for the model was 0.33 and its t-value was 1.61, which is not statistically significant at 10%. These results suggest rejecting the double log model in favor of the linear. This could be explained by taking into consideration that linear forms perform better than logarithmic forms when a variable has not been measured properly, or worse, when a variable is missing. As it was explained before, the nature of the data collected provides the study with such measurement errors.

 If we take a closer look at the results from the fixed linear

Table B.3 Model Results

Model	Random Linear	Random Double Log	Fixed Linear	Fixed Double Log	Pooled Linear	Pooled Log
Income	1.87^b	-3.06	1.80^a	-0.11	0.01	0.40
	(1.94)	(-1.11)	(2.18)	(-0.05)	(0.72)	(0.15)
Price Ent	0.99^a	-5.47	0.93^a	-0.04	0.005	0.57
	(1.97)	(-1.05)	(2.17)	(-0.08)	(0.83)	(0.09)
Price Comp	-0.98	1.01	-1.62^a	-0.08	-0.01	-0.83
	(-1.21)	(0.99)	(-2.24)	(-0.09)	(-0.66)	(-0.35)
Hall	-7.07^a	0.13	-12.74^a	(0.04)	-0.09^a	-0.63^a
	(-2.03)	(1.26)	(-3.37)	(0.18)	(4.38)	(-4.02)
Previous Attendance	0.24	0.88^a	-0.14	-0.11	0.08	0.06^a
	(1.55)	(12.28)	(-0.86)	(-0.44)	(0.67)	(0.68)
Constant	-124.84	33.24				
C-Opening			-93.85	5.16		
C-gourmet			-97.41	4.98		
C-interlude			-85.21	5.62		
C-interme			-86.81	5.72		
C-crescen			-88.14	5.68		
C-chamber			-105.99	3.98		
C-family			-93.89	5		
R-squared	0.86	0.71	0.89	0.84	0.36	0.20
Durbin Watson	1.85	2.52	1.45	1.86	2.07	2.08

t-values in parentheses
a sig. at 5%
b at 10%

model, which will be taken as the best fit for equation B.11, we can see that as the price of subscriptions to the MCB increases, so does the attendance to the NWS. (The cross price elasticity, evaluated at mean values, is 6.2.) The negative sign for the complementary good, restaurant visits, follows economic intuition and is statistically significant. This result supports the contention that cultural consumers do appreciate efforts by the cultural organizations to increase the "value" of their tickets. For instance, one of the programs the NWS has implemented to attract more consumers is a Gourmet Series where the subscriber gets a fifty percent discount at selected restaurants in Miami Beach.

The past attendance's sign does not support the contention that cultural goods are habit forming, however, it is barely statistically significant. The INCOME coefficient is statistically significant and its positive sign behaves as expected. The income elasticity is 2.5 which would imply that the NWS events are in fact luxuries. Finally, the HALL variable takes care of the difference in capacity of the two theaters and the ambiance near it. This space variable illustrates another crucial point as well. The marketing-public relations department at the NWS noticed a drop in attendance to the Gusman Center's concerts. This theater, whose acoustic is ideal for symphony concerts, faces the poignant problem of being located in an area that people find dangerous and unattractive. The NWS believed that by reducing prices, they could lure more concertgoers. But in reality the perceived value effect and the location problems made attendance to drop even lower. The new 1997-98 NWS season will feature no concerts at the Gusman Center. This situation not only points out the importance consumers give to the ambiance of the concert, but also indirectly shows that cultural consumers are not attracted ("fooled") by decreases in prices.

Conclusions

The claim that by lowering prices an Arts organization can appeal to a wider audience was challenged in this study. The results support the economic literature that assumes that people who do not have the acquired taste for the opera or the symphony will not enjoy it even if its for free. On the other end, those who enjoy these cultural activities perceive low prices as a sign that the performance will have a lower quality than normal. This perceived value effect decreases even further attendance to cultural events when prices are reduced in order to fulfill, in this case, the NWS' outreach objectives. To evaluate the perceived value effect more precisely, we could conduct several studies in which we determine the attendance to events when ticket prices are zero. On the other end, a more interesting study could be conducted to assess if these free tickets have an effect in next years' season ticket sales. This would help determine if the claim that attendance to concert series is an acquired taste or if free tickets to cultural activities should be part of an arts education program.

The current study could also be extended by taking into consideration that consumption of events programmed by symphony orchestras is definitely time consuming. This would suggest that the price of leisure time is likely to be more influential in determining demand than the ticket price itself. One could also argue that consumption at time t is positively dependent on consumption at time t-1. This addition to the formulation of the model would acknowledge the "addictive" or "acquired taste" aspect of artistic goods. While we did take into consideration this factor for estimation purposes, the random model was not very significant suggesting the need for more work in this area.

Another improvement to the study is related to the use of data on single ticket sales. An interesting addition to the model could be using single ticket sales to determine how they affect subscription sales, and then study their relationship to average

price for single tickets. This could not be done in this study since the data the NWS keeps for single ticket sales is incomplete and at times incorrect as their computer capabilities were limited in the early 1990s. The same limitation was encountered when trying to gather data to assess the impact complementary or free tickets have on current demand.

To deal with issues of asymmetry of information and its effect on attendance, figures on advertisement are being carefully gathered by the NWS. We could say that as fliers and ads announce what type of program is going to be played, what conductor and soloist have been invited and so on, asymmetry of information is reduced. What is not clear is if this disclosure will deter or attract more customers.

Finally, a better empirical estimate for the INCOME variable should be gathered. From the new records the NWS is gathering, information on the zip codes and addresses of subscribers could be gathered. This would allow us to determine more precisely the characteristics of the NWS market. It would also help us illustrate why subscribers prefer the NWS to any other cultural event and explain how distance affects their decisions.

The improvements of this study rely heavily on the availability of data. The newly installed Marketing Department at the NWS is keeping better track not only of ticket sales and number of free concerts programmed, but also of production cost per concert (which could be used as a proxy for quality) and price schedule (according to seating, age, and student or military discount).

Notes

¹ See discussion of nonprofit organizations in America (Chapter 2).

[2] The modern and permanent acoustic devices at the Lincoln Theater make the listening experience more "pleasant" than at the Gusman Center.

[3] See Chapter 2 on voluntary price discrimination.

[4] See section on limitations of this measure.

[5] One other suggestion was to use the price of single tickets for the NWS. Though this variable would account for readily available substitution and would have provided interesting insights to the NWS itself, their data were quite confusing as sometimes-single tickets, complementary tickets and subscribers exchanges were mixed under the heading of single tickets.

[6] See Chapter 4.

[7] Explained in Chapter 3.

Appendix C

1) GENERAL QUESTIONS: Organization name, contact name and phone number.

2) OPERATING BUDGET: Current Fiscal Year 1994-95
 2.1 Revenues
 - a. Admissions, Memberships, Subscriptions
 - b. Government Grants (Local, State, Federal)
 - c. Private Grants and Contributions (Individual, Corporate and Foundation)
 - d. Interest, Dividends, Endowments
 - e. Other Sources

 2.2 Expenditures
 - a. Total Administrative Clerical Wages and Salaries (including benefits)
 - b. Total Technical Wages and Salaries (including benefits)
 - c. Total Artistic Wages and Salaries -Permanent (including benefits)
 - d. Other Wages and Salaries (including benefits)
 - e. Total Artistic Contracted Services
 - f. Contracted Personnel and Professional Services
 - g. Space Rental, Utilities, Equipment Rental
 - h. Office Supplies
 - i. Marketing and Advertising
 - j. Other

3) CAPITAL EXPENDITURES
 a. New Facility Construction
 b. Renovation and Improvement of Existing Facilities
 c. Purchase of Equipment and Machinery
 d. Other

4) SOURCES OF FUNDING FOR ONGOING CAPITAL EXPENDITURE (in %)
 a. Internal Funds
 b. Federal Grants
 c. State Grants
 d. Local Grants
 e. Private Grants (Individual, Corporate and Foundation)
 f. Private Lenders (Banks and other Financial Lenders)
 g. Other Founding Sources

5) WORK FORCE
 a. Number of Full Time Employees and Payroll
 b. Number of Part Time Employees and Payroll
 c. Number of Volunteer Workers and Number of Hours Worked

6) ATTENDANCE
 a. Number of Performances, Number of People and Dollar Amount of Ticket sold to Performance activities
 b. Number of Performances, Number of People and Dollar Amount of Ticket sold to Exhibitions
 c. Number of Performances, Number of People and Dollar Amount of Ticket sold to Festivals and Special Events.

Study Participants

CULTURAL ORGANIZATIONS (i.e. organizations receiving grants from the Dade Cultural Affairs Council that produce more than one event a year)

Actors' Playhouse
Advancement in Arts
Akropolis Acting Co.
Alliance for Media Arts
Archeological Society of
 Florida
Area Stage Company
Art Museum at FIU
Arts and Business Council
Arts in Public Places
Bakehouse Art Complex
Ballet Etudes of South Florida
Ballet Flamenco La Rosa
Barry University Museum
Bass Museum of Art
Bayfront Park Management
 Trust
Black Archives History
Body Nation Dance Theater
Center for Haitian Studies
Center for the Emerging Arts
Center for the Fine Arts
Children Cultural Group
Children's Touring Dance
Chopin Foundation
Chorale of Greater Miami
City of Opa-Locka

Coalition for Women History
Coconut Grove Playhouse
Concert Association (Florida)
Concert Association
 (Homestead)
Continuum Gallery
Cultural Affairs
Dade County Auditorium
Dade Heritage Association
Dance Arts Foundation
Dave and Mary Alper Center
Deco Echo Artists
Dominican American Group
Fairchild Tropical Gardens
Fantasy Theater Factory
Florida Artists Group
Florida Dance Association
Florida Grand Opera
Florida International University
Florida Philharmonic
Florida Pioneer Museum
Freddick Batcher Company
Gold Coast Theater
Greater Miami Host Committee
Greater Miami Symphonic
Gusman Center

Hispanic Lyric Theater
Historical Museum So Florida
Homestead Center for Arts
Jazz Concert Series at
 University of Miami
Lowe Art Museum
M Ensemble
M.D.C.C. (Art Gallery)
Mal Jonal Productions
Mary Street Dance Theater
Miami Chamber Symphony
Miami City Ballet
Miami Dance Futures
Miami Light Project
Miami Oratorio Society
Miami Shores Theater
Miami Symphony Orchestra
Miami Watercolor
Miami Youth Museum
Middle Beach Partnership
Momentum Dance Company
Museum of Science
Music Concerts Series FIU
National Art Exhibition
New Theater
New World Festival
New World Symphony
N. Miami Beach Concert Band
N. Miami Beach Public Library
One Art
Pan American Artists

Paterson & Dancers
Performing Arts Center Trust
Performing Arts Education
Photogroup Center
Public Library (Miami-Dade)
Public Library (North Miami)
Puerto Rican Forum
Rhythm Foundation
Richmond Heights
Ring Theater
Rotary Club (Key Biscayne)
Sosyete Koukouy
South Dade Community
 Development Association
South Florida Arts Center
South Florida Youth Symphony
Sunrise Community Arts
Temple Beth Am Concerts
Theater Dept. at FIU
Theater League of South
 Florida
Tickets to Paradise
Tigertail Productions
TREX Theater Group
University of Miami
WDNA/FM 88.9 Public Radio
WLRN Public Radio and TV
Wolfsonian
World Resources
YMCA Miami

FESTIVALS (i.e. organizations receiving grants from the Dade Cultural Affairs Council that organize events once year)

Art Deco Weekend
Asian Arts Festival
Banyan Arts & Crafts Festival
Baptists Hospital Artists
 Showcase
Coconut Grove Arts Festival
Coral Gables Festival of Arts
Dade County Youth Fair
Dr. King Jnr. Parade Festivities
Drannoff Piano Competition
Festival Miami
Florida Shakespeare Festival
Goombay Festival
Greater Miami Festivals
 Association
Harvest Festival
Hispanic Heritage Festival
International Hispanic Theater
 Festival

Italian Renaissance Festival
Jazz Under the Stars
Junior Orange Bowl Parade
King Orange Parade
Merrick Festival
Miami Beach Film Festival
Miami Book Fair
Miami Film Festival
Miami Reggae Festival
South Florida Black Film
 Festival
South Florida Bluegrass Festival
Southeast Florida Scottish
 Festival
Subtropics New Music Festival
Sunstreet Festival
Taste of the Grove

Bibliography

Allman, T. (1988), *Miami: La Ciudad del Futuro*. Miami, FL: D.E.L. Publishing House.

Armbruster, A. (1995), *The Life and Times of Miami Beach*. New York: Knopf.

Baumol, W. and Bowen, W. (1966), *Performing Arts: The Economic Dilemma*. Cambridge, MA: MIT Press.

Becker, G. (1996), *Accounting for Tastes*. Cambridge, MA: Harvard University Press.

Bianchini, F. (1993), "Culture, Conflict and Cities: Issues and Prospects for the 1990s", in F. Bianchini and M. Parkison (eds), *Cultural Policy and Urban Regeneration*. Manchester: Manchester University Press, pp. 199-213.

--- , (1993a), "Remaking European Cities: The Role of Cultural Policies", in F. Bianchini and M. Parkinson (eds), *Cultural Policy and Urban Regeneration*. Manchester: Manchester University Press, pp. 1-20.

Bill Communications, *Sales and Marketing Management Survey of Buying Power*, (1977-1996). 20 vols. New York.

Blaug, M. (1992), *The Methodology of Economics*. Cambridge, MA: Cambridge University Press.

Bovaird, T. (1992), "Local Economic Development and the City". *Urban Studies,* vol. 29, pp. 343-368.

Bureau of Investigation, *Uniform Crime Reports for the U.S.*, (1977-1996). 19 vols. Washington, DC.

Cameron, S. (1995), "On the Role of Critics in the Culture Industry". *Journal of Cultural Economics*, vol. 19, pp. 321-331.

Cassel, E. and Mendelsohn, R. (1985), "The Choice of Functional Forms for Hedonic Prices Equations: Comment". *Journal of Urban Economics*, vol. 18, pp. 135-142.

Chasse, J. (1995), "Nonprofit Organizations and the Institutionalist Approach". *Journal of Economic Issues*, vol. 29, pp. 525- 534.

Colonna, C. (1995), "The Economic Contribution of Volunteerism Toward the Value of Our Cultural Inventory". *Journal of Cultural Economics*, vol. 19, pp. 341-350.

Croper, M., Deck, L. and McConnel, K. (1987), *On the Choice of Functional Forms for Hedonic Price Functions*. Washington: Resources for the Future.

Cummings, M. and Davidson, J. (1989), *Who's to Pay for the Arts?* New York: Aca Books.

Cwi, D. (1987), "Improving Economic Impact Studies", in *Economic Impact of the Arts, A Sourcebook.* Denver: National Conference of State Legislatures, pp. 105-126.

--- , (1980), *The Arts Talk Economics*. Washington, D.C.: National Assembly of Community Arts Agencies.

Cwi, D. and Lyall, K. (1977), *Economic Impact of the Arts and Cultural Institutions: A Model for Assessment and a Case Study in Baltimore.* Washington, DC: NEA, Research Division.

Davidson, J. (1980), "Comment", in W. Hendon, J. Shanahan and A. Macdonald (eds), *Economic Policy for the Arts.* Cambridge, MA: Abt Books, pp. 305-307.

--- , (1985), "The Interrelationships Between Public and Private Funding of the Arts in the United States". *Journal of Arts Management and Law*, vol. 14, pp. 77-105.

Day, K. and Devlin, R. (1996), "Volunteerism and Crowding Out: Canadian Econometric Evidence". *Canadian Journal of Economics*, vol. 29, pp. 36-53.

Deaton, A. (1981), "Introduction", in A. Deaton (ed), *Essays in the Theory and Measurement of Consumer Behavior*. Cambridge, MA: Cambridge Press, pp. 2-6.

Deaton, A. and Muellbauer, J. (1980), *Economics and Consumer Behavior*. Cambridge, MA: Cambridge University Press.

New York Port Authority, *Destination New York-New Jersey: Tourism and Travel to the Metropolitan Region*. New York, 1994.

DiMaggio, P., Vseem, M. and Brown, P. (1978), *Audience Studies of the Performing Arts and Museums*. Washington, D.C.: National Endowment for the Arts

--- , (1990), "The Sociology of Nonprofit Organizations and Sectors". *Annual Review of Sociology*, vol. 16, pp. 137-160.

--- , (1987), "Nonprofit Organizations in the Production and Distribution of Culture". in W. Powell (ed), *The Nonprofit Sector*. New Haven: Yale University Press, pp. 195-220.

--- , (1986), *Nonprofit Enterprise in the Arts*. New York: Oxford University Press.

Duffy, T. (1996), "The Leap Frog Effect", in P. Lorente (ed), *The Role of Museums and the Arts in the Urban Regeneration of Liverpool*. Leicester: Center for Urban History, pp. 119-121.

National Endowment for The Arts, *Economic Impact of Arts and Cultural Institutions*. Washington D.C., 1981.

Economist Intelligence Unit, *Country Profile*, (1977 - 1995). 19 vols. London.

Ellin, N. (1996), *Postmodern Urbanism*. Cambridge, Mass: Blackwell.

Evans, R. (1996), "Liverpool's Urban Regeneration", in P. Lorente (ed), *The Role of Museums and the Arts in the Urban Regeneration of Liverpool*. Leicester: Center for Urban History, pp. 7-22.

Florida Department of Development, *Miami Beach Statistical Abstract,* (1995-1996). 2 vols. Miami Beach.

Foley, P. (1992), "Local Economic Policy and Job Creation: A Review of Evaluation Studies". *Urban Studies*, vol. 29, pp. 527-598.

Fox-Przeworski, J. (1991), *Urban Regeneration in a Changing Economy*. Oxford: Clarendon Press.

Frank, R., and Cook, P. (1995), *The Winner-Take-All Society*. New York: Free Press.

Frey, B. and Eichenberger, R. (1995), "On the Rate of Return in the Art Market: Survey and Evaluation". *European Economic Review*, vol. 39, pp. 528-537.

Gapinski, J. (1979), "What Price Patronage Lost? A View From the Input Side". *Journal of Cultural Economics*, vol. 3, pp. 62-72.

--- , (1980), "The Production of Culture". *Review of Economics and Statistics*, vol. 62, pp. 578-586.

--- , (1981), "Economics, Demographics, and Attendance at the Symphony". *Journal of Cultural Economics*, vol. 5, pp. 79-83.

--- , (1984), "The Economics of Performing Shakespeare". *The American Economic Review*, vol. 74, pp. 458-466.

--- , (1985), "Do the Nonprofit Performing Arts Optimize? The Moral from Shakespeare". *Quarterly Review of Economics and Statistics*, vol. 25, pp. 27-37.

González, J. (1993), "Bilbao: Culture, Citizenship, and Quality of Life", in F. Bianchini and M. Parkinson (eds), *Cultural Policy and Urban Regeneration*. Manchester: Manchester University Press, pp. 73-89.

Gramlich, E. (1990), *A Guide to Benefit Cost Analysis*. New Jersey: Prentice Hall.

Grampp, W. (1989), *Pricing the Priceless*. New York: Basic Books.

Greater Miami Chamber of Commerce, *Miami Profiles*, (1990-1996). 7 vols. Miami, FL.

Greene, W. (1993), *Econometric Analysis*. New York: McMillan.

Gujarati, D. (1992), *Essentials of Econometrics*. New York: McGraw Hill.

Hall, P. (1992), *Inventing the Nonprofit Sector*. Batimore: John Hopkins University Press.

Hansmann, H. 1987, "Economic Theories of Nonprofit Organization", in W. Powell (ed), *The Nonprofit Sector*. New Haven: Yale University Press, pp. 27-42.

--- , (1981), "Nonprofit Enterprise in the Performing Arts." *Bell Journal of Economics*, vol. 12, pp. 341-361.

Harvey, E. (1993), *Legislación Cultural*. San Juan: Instituto de Cultura Puerto Riqueña.

Helbrun, J. and Gray, C. (1993), *The Economics of Art and Culture*. New York: Cambridge Press.

Hendon, W. (1981*), Evaluating Urban Parks and Recreation*. New York: Praeger.

Horowitz, H. (1993), "The Status of Artists in the USA". *Journal of Cultural Economics*, vol. 17, pp. 29-48.

Jervins, R. (April 21, 1996), "Lincoln Road without any Art?" The Miami Herald, final ed.: 21.

Jessen, R. (1978), Statistical Survey Techniques. New York: Wiley Publications.

Katz, P. (1994), *New Urbanism*. New York: McGraw Hill.

Logan, J. and Molotch, H. (1987), *Urban Fortunes: The political economy of Place*. Berkeley: University of California Press.

Lorente, P. (1996), "Museums as Catalysts for the Revitalization of Ports in Decline: Lessons from Liverpool and Marseilles", in P. Lorente (ed), *The Role of Museums and the Arts in the Urban Regeneration of Liverpool*. Leicester: Center for Urban History, pp. 36-60.

Luksetich, W. and Lange, M. (1995), "A Simultaneous Model of Nonprofit Symphony Orchestra Behavior". *Journal of Cultural Economics*, vol. 19, pp. 49-68.

Lynch, R. (1993), *The Arts Means Business*, Washington, DC: NALAA.

Marquis, A. (1995), *Art Lessons*. New York: Harper Collins.

Marry, M. and Marry, B. (1980), "The Role of the Arts in Developing Countries: Thailand, A Case Study", in W.

Hendon, J. Shanahan, and A. Macdonald (eds), *Economic Policy for the Arts*. Cambridge, MA: Abt Books, pp. 349-356.

Meir, N. (1990), *Volunteer Resource Guide: Overview*. New York: ABC Council.

Mundlak, Y. (1978), "On the Pooling of Time Series and Cross Sectional Data". *Econometrica*, vol. 49, pp. 1583-1588.

Mukerjee, S. and Witte, A. (1993), "Provision of Child Care: Cost Functions for Profit Making and Not-for-Profit Day Care Centers", in Z. Griliches and J. Mairesse (eds), *Productivity Issues in Services at the Micro Level*. Massachussets: Kluwer, pp. 141-160.

Myerscough, J. (1988), *The Economic Importance of the Arts in Britain*. London: Policy Studies Institute.

Netzer, D. (1978), *The Subsidized Muse*. Cambridge, MA: Cambridge University Press.

Papke, L. (1991), *Tax Policy and Urban Development*. Cambridge, MA: National Bureau of Economic Research Working Paper No. 3945.

Peacock, A. (1994), "The Design and Operation of Public Funding of the Arts: An Economist's View", in A. Peacock and I. Rizzo (eds), *Cultural Economics*. pp. 167-184.

Penne, R. and Shanahan, J. (1987), "The Role of the Arts in State and Local Economic Development", in *Economic Impact of the Arts, A Sourcebook*. Denver: National Conference of State Legislatures, pp. 127-157.

Reese, E. (1989), "A Historic Interpretation of Art Deco and Arquitectonica", in *Research Reports on Miami*, Miami: FIU.

Pignataro, G. (1984), "Imperfect Information and Cultural Goods", in A. Peacock and I. Rizzo (eds), *Cultural Economics*. Netherlands: Kluwer Academic Publisher, pp. 55-68.

Pommerehne, W. and Frey, B. (1993), "Justification for Art Trade Restrictions: The Economic Perspective". *Ettudes en Droit de l'Art*, vol. 3, pp. 89-114.

--- , (1990), "Public Promotion of the Arts: A Survey of Means". *Journal of Cultural of Economics*, vol. 14, pp. 73-95.

Radich, A. and Foss, S. (1987), "Effective Advocacy", in *Economic Impact of the Arts, A Sourcebook*. Denver: National Conference of State Legislatures, pp. 77-104.

Raley, H., Polansky, L. and Millas, A. (1994), *Old Miami Beach: A Case Study in Historic Preservation.* Miami, FL: Miami Design Preservation League.

Ratcliffe, J. and Stubbs, M. (1996), *Urban Planning and Real Estate Development*, London: UCL Press.

Reinhardt, U. (1975), *Physician Productivity and the Demand for Health Manpower*. Cambridge, MA: Ballinger.

Rosner, D. (1980), "Gaining Control: Reform, Reimbursement and Politics in New York's Community Hospitals, 1890-1915". *American Journal of Public Health*, vol. 790, pp. 533-542.

Rothenberg, J. (1967), *Economic Evaluation of Urban Renewal.* Washington D.C.: The Brookings Institution.

Salamon, L. (1987), "Partners in Public Service", in W. Powel (ed), *The Nonprofit Sector*. New Haven: Yale University Press, pp. 99-117.

Seaman, B. (1987), "Economic Impact Studies", in *Economic Impact of the Arts, A Sourcebook.* Denver: National Conference of State Legislatures, pp. 43-76.

Shanahan, J. (1980), "The Arts and Urban Development", in W. Hendon, J. Shanahan, and A. Macdonald (eds), *Economic Policy for the Arts*. Cambridge MA: Abt Books, pp. 295-305.

Smith, S. and Smith, V. (1986), "Successful Movies: A Preliminary Empirical Analysis". *Applied Economics*, vol. 18, pp. 501-507.

Florida Department of Commerce, *Florida Tourism and Historic Sites*. Tallahassee, 1988.

Starret, D. (1988), *Foundations of Public Economics*. Cambridge: Cambridge University Press.

Steinberg, R. (1986), "Should Donors Care About Fundraising?", in S. Ackerman (ed), *The Economics of Nonprofit Institutions*. New York: Oxford University, pp. 347-364.

Sudbury, P. and Forrester, J. (1996), "Some Museums Development in Liverpool. The Benefits to the Community", in P. Lorente (ed), *The Role of Museums and the Arts in the Urban Regeneration of Liverpool*. Leicester: Center for Urban History, pp. 71-89.

Svendsen, A. (1992), "Fragmentation in Diverse Cultural Demand". *Journal of Cultural Economics*, vol. 16, pp. 83-92.

Swanstrom, T. (1993), "Beyond Economism: Urban Political Economy and the Postmodern Challenge". *Journal of Urban Affairs*, vol. 9, pp. 55-78.

Taylor, R. (1986), "Television Movie Audiences and Movie Awards: A Statistical Study". *Journal of Broadcasting*, vol. 18, pp. 181-186.

Throsby, D. (1995), "The Production and Consumption of the Arts". *Journal of Economic Literature*, vol. 32, pp. 1-29.

--- , (1977), "Social and Economic Benefits from Regional Investment in Arts Facilities: Theory and Application". *Journal of Cultural Economics*, vol. 6, pp. 1-14.

Tiebout, C. (1956), "A Pure Theory of Local Expenditure". *Journal of Public Economics*, vol. 64, pp. 416-424.

Towse, R. (1992), *Cultural Economics*. New York: Springer-Verlag.

Tourism and Cultural Commission, *Funding for Cultural Organizations, Programs and Facilities*. Tallahassee, 1995.

Tourism and Cultural Commission, *Historic Property Appraisal and Assessment Practices*. Tallahassee, 1995.

U.S. Department of Commerce Bureau of the Census, *Governmental Finances* (1977-1995). 19 vols. Washington D.C.

U.S. Department of Commerce Bureau of the Census, *Statistical Abstract of the United States*, (1977-1995). 19 vols. Washington, D.C.

U.S. Department of Labor, *CPI Detailed Report*, (1977-1995). 19 vols. Washington, D.C.

Van Tuyl, P. (1996), *Outlook for Cultural/Heritage Tourism*. Washington, DC: NEA.

Vaughan, D. (1980), "Does a Festival Pay?", in W. Hendon, J. Shanahan, and A. Macdonald (eds), *Economic Policy for the Arts*. Cambridge, MA: Abt Books, pp. 308-315.

Villamil, J. (1996*), The Economic Impact of Florida International University*. Miami, FL: Washington Economic Group.

Greater Miami Conventions & Visitors Bureau, *Visitor Profile and Tourism Impact*. Miami, FL., 1994.

Wassmer, R. (1994), "Can Local Incentives Alter a Metropolitan City's Development?" *Urban Studies* vol. 31, pp. 1251-1278.

Weisbord, B. (1988), *The Nonprofit Economy*. Cambridge, MA: Harvard University Press.

Whitehead, J. (1973), *The Separation of College and State: Columbia, Darmouth, Harvard and Yale, 1776-1876*. New Haven: Yale University Press.

Whithers, G. (1979), "Private Demand for Public Subsidies: An Econometric Study of Cultural Support in Australia". *Journal of Cultural Economics,* vol. 3, pp. 53-61.

Wildsain, D., and J. Wilson (1991), "Theoretical Issues in Local Public Economics: An Overview". *Regional Science and Urban Economics* , vol. 21, pp. 317-331.

Zukin, S. (1995), *The Cultures of the Cities*. Cambridge: Blackwell Publisher.